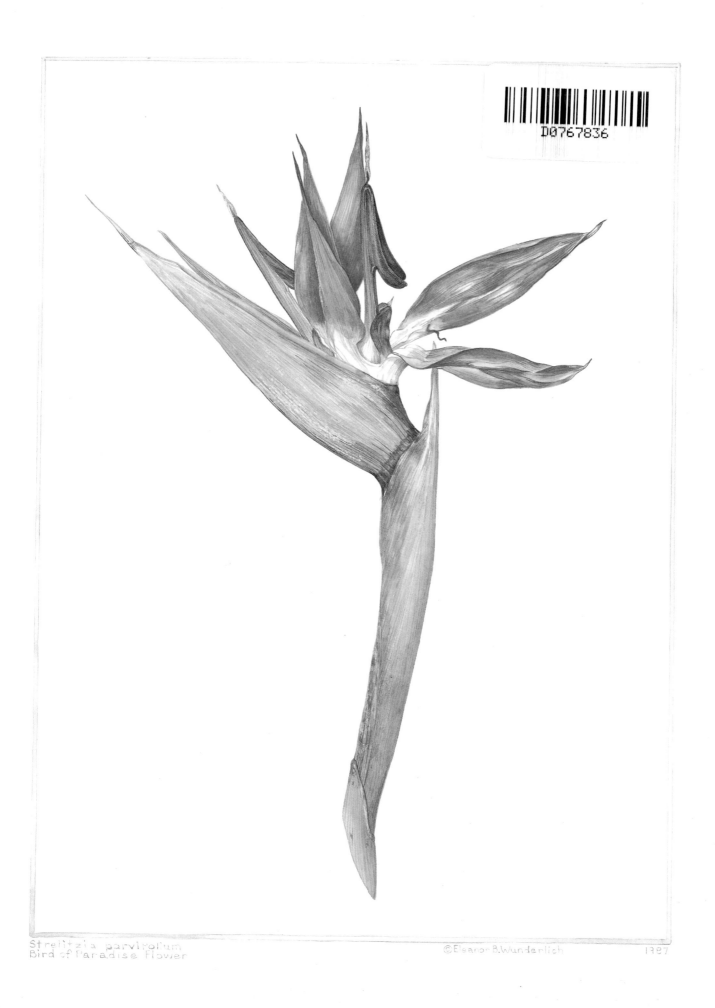

Strelitzia parvifolium
Bird of Paradise Flower

©Eleanor B.Wunderlich

1987

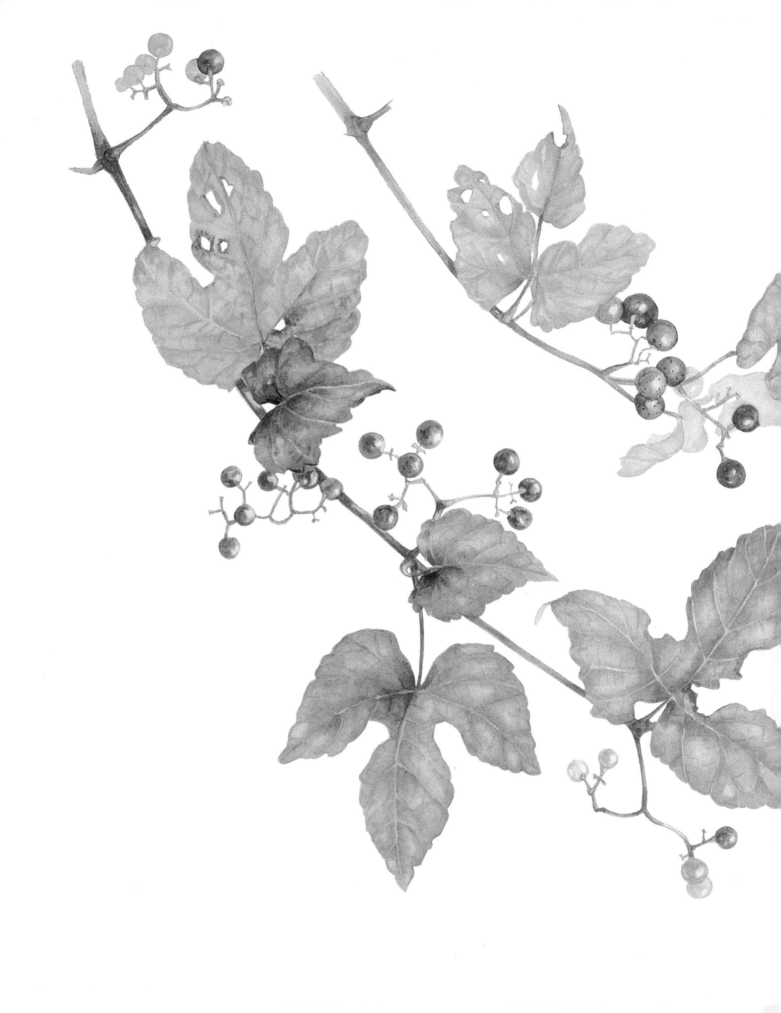

BOTANICAL ILLUSTRATION IN WATERCOLOR

ELEANOR B. WUNDERLICH

WATSON-GUPTILL PUBLICATIONS/NEW YORK

Paperback Edition 1996

Copyright © 1991 Eleanor B. Wunderlich

First published in 1991 in the United States by Watson-Guptill Publications,
a division of BPI Communications, Inc.,
770 Broadway, New York, NY 10003

Library of Congress Cataloging-in-Publications Data

Wunderlich, Eleanor B.
 Botanical illustration in watercolor / Eleanor B. Wunderlich.—Pb ed.
 p. cm.
 Includes bibliographical references and index.
 ISBN 0-8230-0530-5.
 1. Botanical illustration—Technique. 2. Watercolor painting—
Technique. I. Title.
QK98.24. W86 1991
751.42'2434—dc20 91-3257
 CIP

Distributed in Europe, the Far East, Southeast and Central Asia, and South
America by Roto Vision S.A., 9 Route Suisse, CH-1295 Mies, Switzerland.

Manufactured in Malaysia

3 4 5 6 7 8 9 0 / 05 04 03 02 01 00

CONTENTS

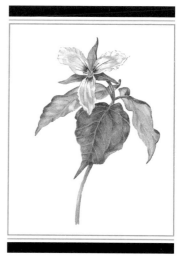

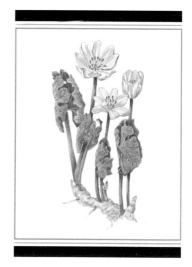

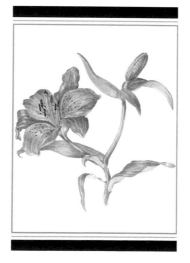

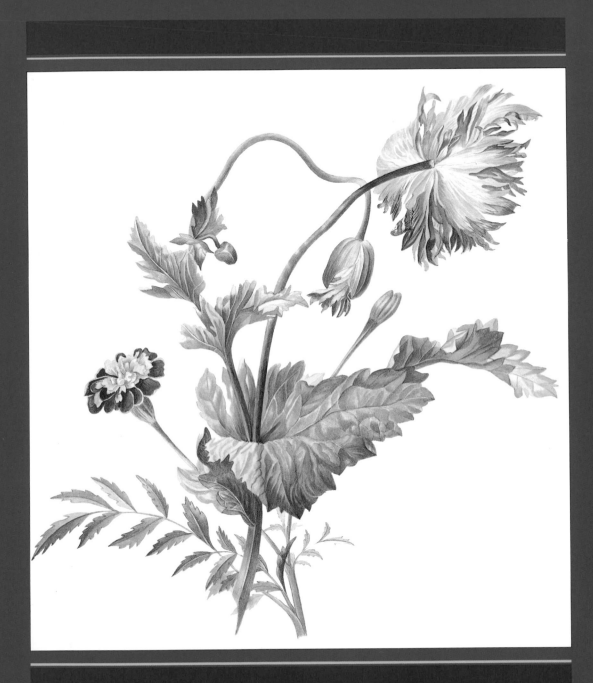

INTRODUCTION

Throughout the centuries, artists have portrayed the beauty of plants in different mediums for different reasons. The Egyptians stylized lotus blossoms for formal designs; the early Greeks employed the acanthus leaf in the Corinthian column; flowers and insects embellished the borders of the pages of illuminated manuscripts during the Middle Ages. With the invention of movable type in the fifteenth century, printing presses were built throughout Europe to meet the demand for books made available for the first time to the general public. Those most sought-after were the herbals, which described plants, attributed specific healing qualities to them, and gave recipes for medicinal concoctions. These books were illustrated with block prints of varying quality and design. Many of the plants pictured were imaginative inventions of the artist, and some were based on hearsay descriptions of plant exotica—but others were attempts at accurate depictions.

It wasn't until the sixteenth century that a specific type of painting done with water-soluble paints was developed: the botanical watercolor. This resulted from Europe's growing passion for flowering garden plants, which by then were being imported from throughout the known world and introduced into formal Renaissance gardens. The growing enthusiasm for colorful flowering plants to replace the fenced medieval herb and vegetable garden soon created a demand by wealthy amateurs for sumptuous picture books in which flowers were presented with technical brilliance by artists of the High Renaissance. By the middle of the sixteenth century, following the establishment of the first botanical gardens, artists were producing paintings that were scientific in nature.

Since that time, botanical illustration in watercolor has remained very much the same: a specific branch of scientific illustration in a specific medium. The goals of every botanical illustrator are to depict a plant or its parts in accurate detail so that it is identifiable, and to show its growth habits. The techniques for accomplishing this today are very similar to those first developed more than three hundred years ago. Luckily, artists no longer have to grind their own paints, search out appropriate paper at the mills, use bread for an eraser, or work by the light of oil lamps. Most of the necessary supplies are within easy reach at local art supply stores or through mail-order catalogs.

Many beautiful books of botanical works of art have already been published, and more will be forthcoming as new artists are discovered or existing collections are made available for reproduction and publication. Most of these books are directed toward specific eras or centuries, the works of one particular artist, or one specific genus of plant life—roses or orchids, for example. We are fortunate to have fine books available on scientific illustration that address the various methods and mediums for picturing natural objects, whether they be animal, vegetable, or mineral. Most of these books, however, give very little information on the techniques or uses of watercolor.

To the best of my knowledge, this book is the first to be devoted entirely to

MARIGOLD AND POPPY

ANONYMOUS. CIRCA 1790–1800. FRENCH.

WATERCOLOR AND GOUACHE ON PAPER.

16 × 12½″ (41 × 32 CM). PRIVATE COLLECTION.

This member of the lily family is unidentified. The gold leaf border was burnished to a high shine with a marble pestle. Bessa was one of the many fine French artists who made up the "Golden Age of Redouté" (1780–1840). Whereas the vast majority of botanical works show plants as close to life size as possible, Bessa's watercolors were done in octavo size, approximately 8 × 5", the plants painted in miniature. Engravings that were exact reproductions of the originals were made for books.

BULB AND FLOWER

PANCRACE BESSA (1772–1835),
PAINTED CIRCA 1815.
WATERCOLOR AND GOUACHE
ON VELLUM,
8 × 5" (20 × 13 CM).
PRIVATE COLLECTION.

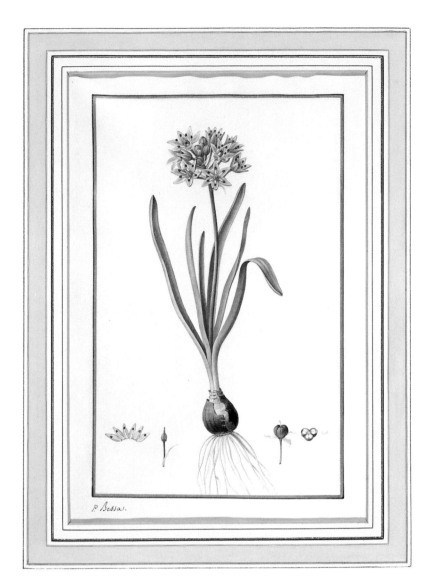

botanical illustration in watercolor. I have tried to show how to use pigments and brushes to re-create plant life in all its delicacy and variety. All botanical illustrators using watercolor—those who have studied with instructors and those who have "gone it alone"—have had to think through and devise working methods. Often quite by accident, they discover and apply centuries-old systems. I believe that this book will fill a void by assisting artists—beginners and professionals alike—who until now have had nowhere to turn for information. Since the object is to render a botanically accurate illustration, the botanical illustrator needs a

knowledge of basic perspective and the use of colors and brushes, and more than a nodding acquaintance with the vast science of botany. The skills and knowledge required for botanical illustration cannot be acquired overnight.

This book contains some basic information useful to any botanical illustrator, but its focus is on watercolor. Those wishing to use other color mediums (such as gouache, acrylics, colored pencils, or oils) or black-and-white techniques (such as pen and ink, carbon dust, or scratchboard) must go elsewhere for information. Remember that there are no rules to prevent

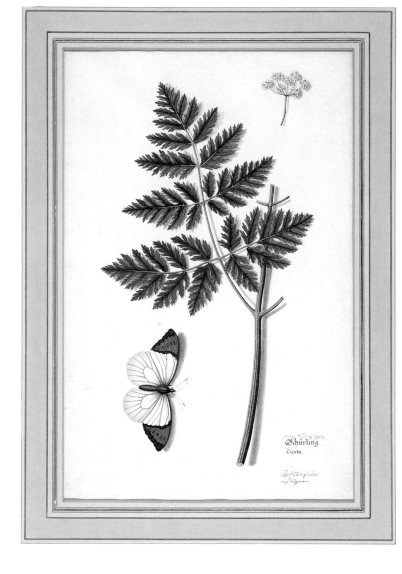

Hemlock consists of a group of poisonous plants of the carrot family, with small, white flowers and finely divided leaves. This picture is from a large collection of delicately painted botanical works possibly done in preparation for an eighteenth-century book that was never published. The shadows behind the forms give a three-dimensional look to the picture but are rarely seen in botanical illustration because they are an unnecessary addition to a scientific rendering.

HEMLOCK

(Circuta)

ANONYMOUS, CIRCA 1790.

AUSTRIAN WATERCOLOR ON PAPER,

14 × 9″ (36 × 23 CM).

PRIVATE COLLECTION.

you from combining several different mediums to achieve your goal. Many artists use paint, inks, pencils—whatever is necessary to obtain the effects they want. This is why it is helpful to be familiar with the many means and materials available. As in all other kinds of creative work, the skills, knowledge, dexterity, and imagination of the individual artist will determine whether the finished piece of artwork is well done and satisfying.

As with any field of endeavor, there are many ways to learn botanical illustration. Take whatever courses are available, and listen to the instructors. Study the work of others in museums and art galleries. Read books on the subject. Most important, apply your skills and knowledge by putting brush to paper—every day, if possible. Experience teaches the artist what works and what doesn't.

Any painting process is difficult to describe in words and far easier to demonstrate in person! Even so, this book is meant to make the learning process a little easier and more satisfying for anyone interested in botanical illustration, whether just entering the field or already well launched into this specific, highly disciplined field of painting.

P A R T O N E

Subject Matter

JACK-IN-THE-PULPIT

WHAT TO PAINT

The botanical world is so huge that the question of what to draw and paint is a matter of many choices for the botanical illustrator. Some artists narrow the field to plant families or one particular genus. Others devote themselves to wildflowers, or trees, or ferns, while others concentrate on the study and illustration of mushrooms and fungi of all descriptions. Artists may also concentrate on plants growing in specific environments such as wetlands, arid deserts, tropical forests, or northern tundra.

Plant subjects for painting are in view all year. Dried leaves, bark, nuts, and all other fruits are good subjects. African violets, paperwhite narcissus, amaryllis, hyacinth, Boston fern, and philodendron are among the many household plants that pro-

vide flowers or foliage in winter. Small cacti in pots and dish gardens are available year round. Fruits and vegetables, as well as cut flowers, can be bought from food markets. Flowers are flown in daily from countries around the world, so a wide variety of exotic plants can be had at local florists. Always ask the florist for the name of the flower or plant you buy, so that you can label the picture accurately.

No great outlay of money is required for plant material. One or two stems from a florist shop, or a couple of pieces of fruit, can be adequate for a picture. Exotic plants such as orchids are more expensive but can be bought singly. They will reward you by lasting for weeks so that ample time can be given to the picture without the flower fading.

FRUITS AND VEGETABLES

Unlike some varieties of flowers, fruits and vegetables are available all year long. They also have the advantage of being far less costly than flowers bought at florist shops. Paintings of fruit have been desirable decorative objects for years and require the same

careful thought and attention to detail as any other botanical subject. Fruits and vegetables are sources of lovely rich colors, such as those found in a peach or eggplant. They also offer complex patterns, such as the veins in a spinach leaf.

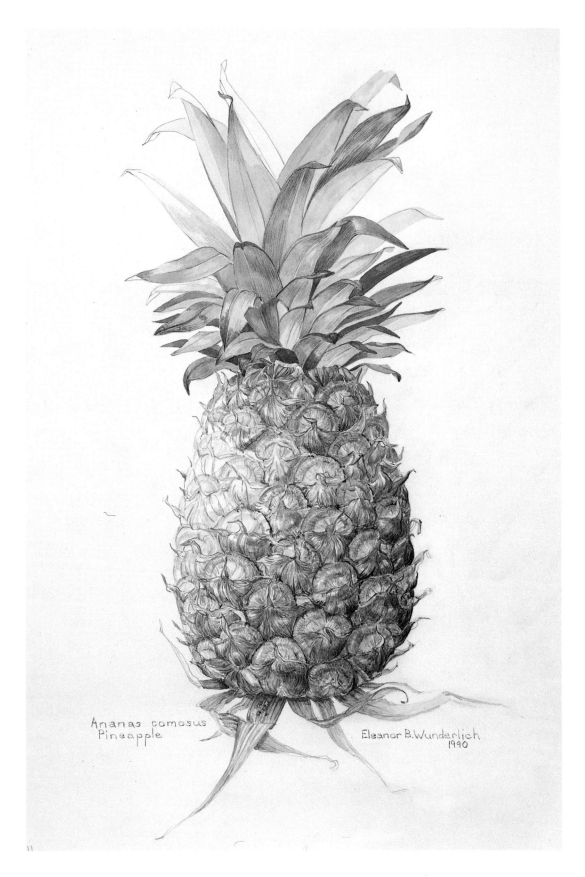

This rendering of a pineapple has a considerable amount of pencil work on it to help create the ragged textures of the different surfaces on the fruit. Some places were left unpainted to give added contrast between the light and dark areas.

PINEAPPLE

(Ananas comosus)

WATERCOLOR ON T. H. SAUNDERS 140 LB. HOT-PRESSED PAPER, 1990, 14 × 9″ (36 × 23 CM). COLLECTION OF THE ARTIST.

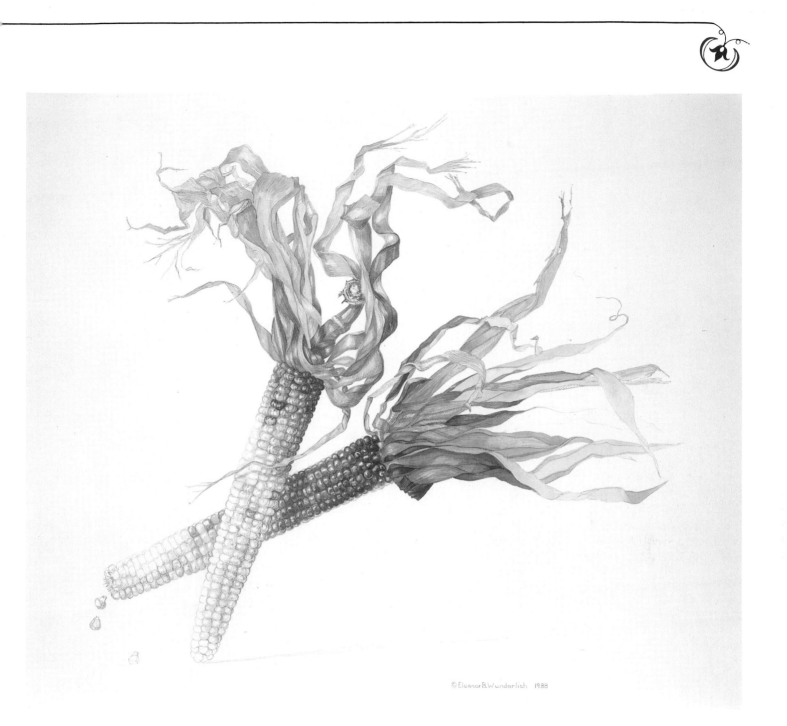

© Eleanor B. Wunderlich 1988

Ornamental, or Indian, corn is an example of decorative
botanical material available in the supermarket or at roadside
stands. Unlike living plants and cut flowers that are likely
to change position, the corn stays steadily in place and will
last for months. These dried husks were thick and profuse,
so I thinned them carefully to create a more orderly design.

INDIAN CORN

(Zea mays)

WATERCOLOR ON ARCHES 140 LB.
HOT-PRESSED PAPER,
1988, 18 × 17" (46 × 43 CM).
PRIVATE COLLECTION.

Stems and leaves can play an important part in botanical illustration. These tulips with their spectacular blossoms are held aloft on curving stems that form a strong element of design in the picture. One leaf was all that was needed for descriptive purposes.

PARROT TULIPS

(HYBRIDS)

WATERCOLOR ON ARCHES 140 LB.

HOT-PRESSED PAPER,

1990, 15 × 11" (38 × 28 CM).

COLLECTION OF THE ARTIST.

Parrot tulips

Eleanor B. Wunderlich 1990

*C*ultivated flowers are the easiest to obtain on a year-round basis. Those fortunate enough to have a garden can cut fresh material that will last several days. Spring bulbs, flowering shrubs, and fruiting trees are inspiring subjects. Annuals planted from seeds are immensely satisfying subject matter. Zinnias, single and double petunias, marigolds, pansies—all are worthy of painting with the brightest possible colors.

A trip to the florist will result in exotic blossoms, and commercial greenhouses are another source of cultivated plants. With so many hybrids on the market, a good book on cultivated flowers is helpful for identifying plants. Remember, though, that no book can cover all the different species and varieties in any given genus because flowering plants are constantly being bred and improved by horticulturists.

WILDFLOWERS

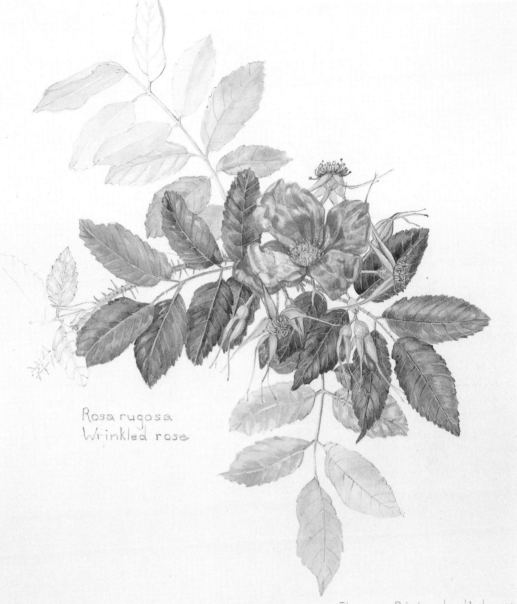

Rosa rugosa
Wrinkled rose

Eleanor B. Wunderlich 1990

Wild rose bushes can grow to tremendous size and often bury their blossoms in foliage. The blossom of this wrinkled rose (Rosa rugosa) *was drawn and painted first. After removing excessive foliage from the flowering branch, I added some of the leaves to the picture. Numerous buds surround the flower to indicate the plant's profuse flowering habit. The pale leaves in the background, some with only a pale wash of color, give an added dimension to the picture.*

WRINKLED ROSE

(Rosa rugosa)

WATERCOLOR ON ARCHES 140 LB.
HOT-PRESSED PAPER,
1990, 11 × 8" (28 × 20 CM).
COLLECTION OF THE ARTIST.

Wild plants abound, and most are free for the taking. Small wild plants can be dug up and potted. By thus keeping the root system intact, you are providing the stems, leaves, and flowers with nourishment, and the entire plant will keep much longer than if the blossoms are simply picked. However, anyone picking or digging up wild plants must be aware of those protected under the federal environmental conservation laws and any state laws that protect locally threatened or endangered species (such as the cacti of Arizona). Such protected plants may not be removed from public lands. Libraries and bookstores have excellent field guides that will help you to identify wild plants. Lists of protected species can be obtained from state conservation departments, wildlife and field museums, and botanical gardens.

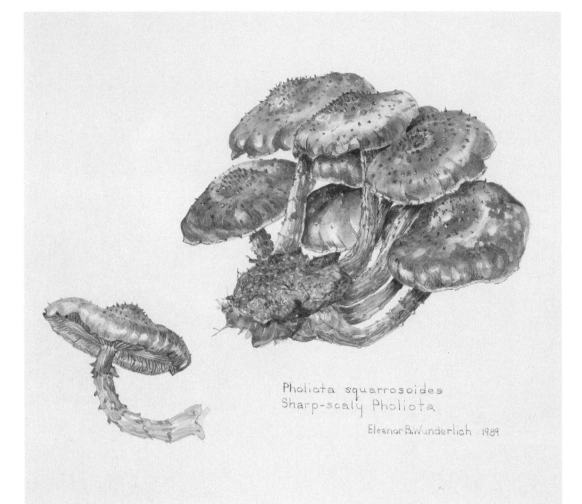

This is a reddish-brown, edible mushroom often found growing in abundance on beech or maple logs. I used a penknife to detach a piece of the bark with its attached cluster of mushrooms and carefully carried it back to my studio. The top mushrooms cast deep, rich, dark brown shadows on those growing up underneath, creating interesting contrasts of lights and darks.

SHARP-SCALY PHOLIOTA

(Pholiota squarrosoides)

WATERCOLOR ON ARCHES 140 LB.
HOT-PRESSED PAPER,
1989, 8 × 9" (20 × 23 CM).
COLLECTION OF THE ARTIST.

Among nonflowering plants, mushrooms and other fungi are some of the most fascinating. Mushrooms can crop up in the space of a few hours on lawns or in the woods, and they are particularly abundant after rain. Mushrooms, like other plants, have specific growing times. Some are found only in the spring months, while others appear in the summer continuing into the late fall. Some species overwinter and can be found by the sharp-eyed observer in January and February.

Shelf fungi, usually growing from the sides of dead tree trunks, are generally hard-surfaced and inedible, a notable exception being the chicken mushroom *(Laetiporus sulphureus)*, a delicious and desirable species. Because of their interesting forms and multiple colors, they should not be overlooked as subject matter.

If you decide to draw and paint mushrooms, it is essential to know something about them. Some of the most beautiful are also the most poisonous. No mushroom should be left in a kitchen or near food unless the picker is positive of its edibility; the thousands of tiny spores can spread to surrounding surfaces. Drawing and painting wild mushrooms, however, is in no way hazardous as long as the artist's hands are washed after handling them. Many field guides will help with identification.

BULBS, UNDERGROUND STEMS, AND ROOTS

The leek in this painting makes a strong linear design in contrast to the roundness of the onion. Note the many textures in this picture: the shiny skin of the onion bulb; the dry, papery quality of its withered leaves; the thick, interfolded leaves of the leek; and its delicate pale roots. (To see how the texture of the onion was built up with several layers, turn to pages 127–128).

YELLOW ONION AND LEEK

(Allium cepa and *Allium porrum)*
WATERCOLOR AND GOUACHE
ON ARCHES 140 LB.
HOT-PRESSED PAPER,
1988, 18 × 15" (46 × 38 CM).
COLLECTION OF THE ARTIST.

Bulbs are good subjects for drawing and painting, particularly while they are growing and developing from one stage to another. Their roots, like other types of root systems, can form an essential and decorative part of a picture, with colors ranging from off-white through the browns, dark grays, purples, and blues. Lily bulbs are composed of fleshy, overlapping scales and vary greatly in size and shape. Irises grow from rhizomes; gladioli grow from corms, which are short, erect, fleshy underground stems. The root tendrils reaching out for nourishment and water in their natural habitats can add a strong element of design to a painting.

Some wild plants have particularly interesting root systems. The bloodroot, a lovely small white member of the poppy family, can be dug out of the ground without damage to reveal a prominent root stock that "bleeds" when cut. Skunk cabbage, probably one of the most maligned of wild plants, is stunning when young, with a handsome root system that has to be one of the hardest to dig out of its habitat of shallow water and mud.

These basic beginnings of plants should not be overlooked by artists. They are an integral part of all plants, of great value in identification, and aesthetically pleasing in a picture.

The Christmas fern stays green all winter though its stalk becomes very fragile by winter's end. This piece broke in three pieces and had to be held together with transparent tape while the picture was being done.

By digging beneath the soil, I unearthed a tightly coiled clump of fiddleheads, curled up and ready to unfurl with the first warm weather.

The sori are shown on the backs of the upper leaflets on the fertile frond that curls downward toward the right.

CHRISTMAS FERN

(Polystichum acrostichoides)

WATERCOLOR ON 140 LB. ARCHES
HOT-PRESSED PAPER,
1990, 18 × 14″ (46 × 36 CM).
COLLECTION OF THE ARTIST.

Polystichum acrostichoides
Christmas Fern

Eleanor B. Wunderlich
February 1990

Most ferns are protected by federal laws, except the sensitive and hay-scented ferns and bracken. However, ferns may be picked or dug out of the ground on privately owned property (with the owners' permission). They can also be bought in pots at commercial nurseries, some of which specialize in woodland plants and offer many exotic species. If given proper care in pots, ferns will last several weeks indoors before planting.

In technical books and field guides, ferns are often depicted bent sharply in the middle in order to fit the entire plant on the page. Unless the illustrator is working on a scientific treatise of one kind or another, it makes for a more artistic rendering to show the fronds in graceful arcs even though some stem may have to be omitted to fit the drawing onto the page.

Ferns form a beautiful background for flowering plants. Though they require a painstaking amount of time to paint, the intricate delicacy of their leaves makes them well worth the effort.

MOSSES

Mosses can be found growing in tight clumps or fairly loose clusters. They like the sides of trees and decaying logs, and also grow in fields and bogs. A magnifying glass is almost a necessity when drawing and painting these small, delicate plants.

HORSETAILS, QUILLWORTS, AND SPIKE AND CLUB MOSSES

Identifying and painting such plants as the horsetails, quillworts, spike mosses, and club mosses will involve the artist in a fascinating branch of botany. Horsetails, which descend from huge trees of prehistoric times, are low-growing jointed plants with hollow stems. Quillworts are mainly aquatic, while spike and club mosses are found in open woods and acidic soil. Best known of the club mosses is probably the ground pine used in Christmas decoration. A magnifying glass is recommended.

VINES

Cultivated and wild vines are among the most decorative plant forms to paint because they can curl, curve, and twist across the paper. Many vines are invasive intruders to North America that can be cut with abandon from their habitats. The Japanese bittersweet, Japanese honeysuckle, and kudzu vine all are threats to native plants because of their strangling growth but are lovely to look at. Wild and domestic grapes, trailing myrtle, and the ivies, to name only a few, are easily available.

Vines can be made to curl across the paper to suit the artist's fancy, without sacrificing botanical accuracy at all.

RUSSULA MUSHROOM SP. AND CLIMBING FALSE BUCKWHEAT

(*Russula emetica* and *Polyganum scandens*) WATERCOLOR ON ARCHES 140 LB. HOT-PRESSED PAPER, 1989, 10 × 11" (25 × 28 CM). COLLECTION OF THE ARTIST.

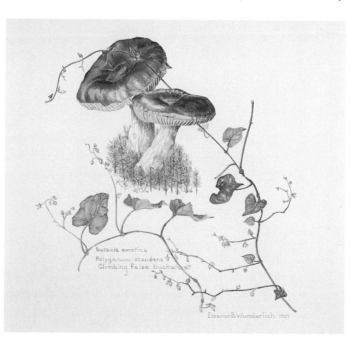

TREES AND SHRUBS

Found on the ground in November, this short branch of the red oak still retained color and interesting surface texture. Some of the leaves were removed to clarify the growth pattern for the viewer and to keep the overall form from becoming too cluttered. The browns, or earth colors, are easy-handling paints. A close scrutiny showed many other colors—blues, reds, and yellows. I also paid careful attention to the twig, whose knobby protrusions form a distinctive feature of the tree.

NORTHERN RED OAK

(Quercus rubra)

WATERCOLOR ON T. H. SAUNDERS
140 LB. HOT-PRESSED PAPER
WITH GOUACHE IN BLUISH AREAS,
1991, 11 × 13" (28 × 33 CM).
COLLECTION OF THE ARTIST.

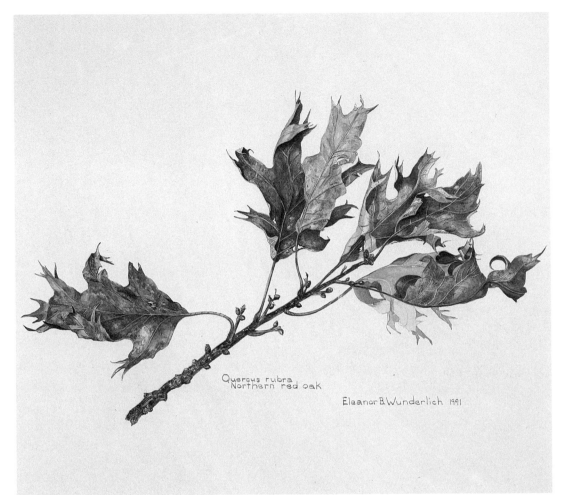

Quercus rubra
Northern red oak

Eleanor B. Wunderlich 1991

Most trees and shrubs are sketched and painted outdoors—for the obvious reason that they are too large and too firmly rooted to bring indoors! However, small parts of larger plants can easily be brought into the studio. Even in winter, small branches, pieces of bark, needles and cones from the conifers, and the long shiny leaves of the rhododendron make convenient subjects for a painting.

Many trees, such as magnolias, catalpas, and tulip trees, bear stunning flowers. Smaller, less conspicuous blossoms such as those found on witch hazel, maples, and linden (basswood) are equally lovely subject matter. The leaves of virtually all trees and shrubs form handsome patterns worthy of painting. Shrubs deliberately planted around suburban homes or growing wild in fields and forests present a broad array of leaves, flowers, and fruits.

A small "cameo" representation of the whole tree or shrub in reduced scale can be done in a corner of the picture when only one or two parts of the whole are being done full size.

This wild viburnum blooms in late May at the edge of deep woods, the large white flowers like bright patches of lace against the dark of the forest. The red berries are formed by August. Hobblebush gets its name from the resiliency of its branches, which according to legend were used by Native Americans to hobble their horses. More likely is its ability to entangle and trip up the feet of the unwary hiker.

I painted the flower first, with its adjacent foliage, and added the fruiting branch three months later. Several hours were spent painting the leaves, starting with a first overall coat of pale green. The final addition was the application of the fine lines between the veins, which give the leaves their characteristic crinkled appearance. The actual leaf surface is a flat, matte green without bright highlights. This type of work takes patience and cannot be accomplished in one sitting.

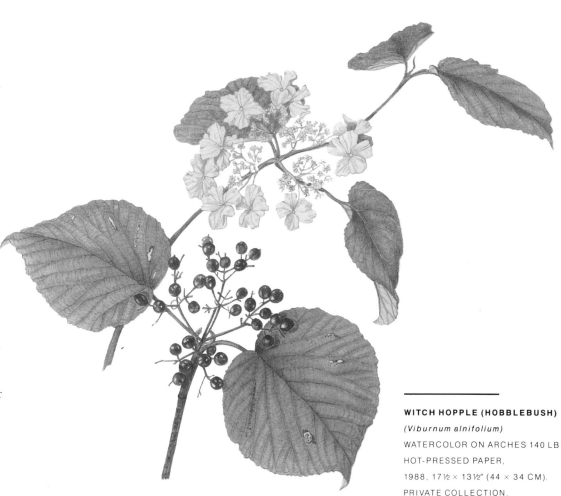

WITCH HOPPLE (HOBBLEBUSH)
(Viburnum alnifolium)
WATERCOLOR ON ARCHES 140 LB.
HOT-PRESSED PAPER,
1988, 17½ × 13½" (44 × 34 CM).
PRIVATE COLLECTION.

USING REFERENCE PHOTOGRAPHS

Photographs of plants can be of some help as reference material, but no photo can take the place of the actual plant. Copying a photograph results in a lifeless, static picture with many details of the plant structure indiscernible. By the same token, copying the works of other artists in any form (oil paintings, watercolors, prints, or drawings) will end with an uninteresting, flat portrayal. (Some beginning illustrators try to copy a photographic reproduction of a print made from a watercolor of a living plant—but by then they are so far removed from their real subject matter that nothing can be learned or accomplished by this exercise.) Works by other botanical illustrators can and should be studied carefully in order to understand different painting techniques and to see how specific problems arising in botanical illustration have been handled. Use other people's work for guidance and ideas, but use nature as your subject.

Materials & Tools

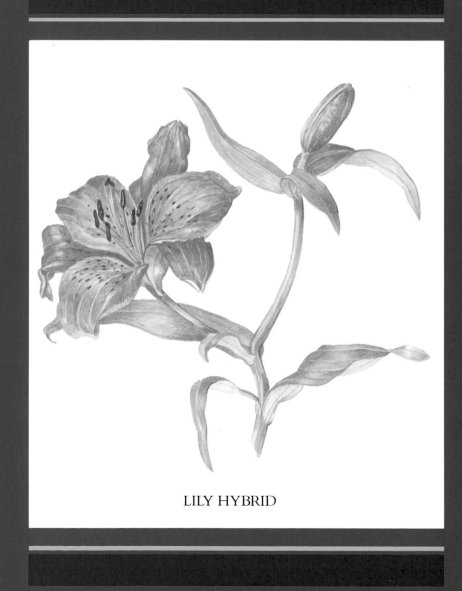

LILY HYBRID

ARTISTS' SPACE AND SUPPLIES

So much material for artists and crafts-people is available on today's market that it is easy to go overboard and invest in too many things—including some that are never used. Most botanical illustrators want to acquire only what they really need, but they can be confused by the hundreds of magazine articles and books on water-color painting. Every artist recommends something different, until the list of supplies seems overwhelming.

This chapter on space and supplies is meant as a guide to shorten the long route of trial and error that many of us have traveled. This is an incomplete listing, since artists are inherently imaginative and will devise many ways of doing a picture using all kinds of items. But the basics are here and have proved to be tried and true. We'll begin with a quick overview of many miscellaneous supplies before looking at paints, brushes, and paper in more detail.

Studio

Probably no artist ever has enough space, but the botanical illustrator is fortunate in not needing a huge studio. There should certainly be an adequate working area set aside just for drawing and painting; a storage space for papers and finished pictures; bookshelves to house a library of pertinent publications; and containers of some sort to hold paints, brushes, pencils, and other necessities.

Drafting Table and Chair

Any site that has to be cleared off throughout the day, such as a dining-room or kitchen table, a dressing table, or a desktop, is hardly conducive to the concentration necessary to create a picture. As some astute artist once observed, it is hard enough to paint without having to fight the environment! A drafting table at least 30 × 40″ (76 × 102 cm) is well worth the expense and available at art supply stores. Another must is a good artist's chair with an adjustable seat that raises and lowers.

Bookcase

A bookcase is extremely useful because many books and periodicals touch in one way or another on botanical illustration. Works of botanical illustrators in books and exhibition catalogs, magazine articles, and illustrated calendars and cards should all be kept for reference. Books and articles on the business aspects of illustration are a necessity. A bookcase will also attract any number of odds and ends such as jars for water, holding devices for plants, and boxes for tubes of paint, to name a few.

Shelving

Stacking drawers or wide shelves are essential for holding paper supplies, mats and mat board, tracing paper, and finished work. Here again, art supply stores have a variety of stacking drawers, some with special areas set aside to hold paints, brushes, and other supplies as well as the flat material.

Lighting

Artists vary in their opinions on lighting. Some flatly refuse to work under fluorescent light, observing that it alters colors of both plants and paints. Certainly a studio with skylights or windows facing north is the ideal situation, but this is not always possible. Lack of "perfect lighting" is no excuse for not drawing or painting. Many artists' lamps and desk lights are mounted on swing bars so that they can be raised and lowered, tilted, and adjusted from side to side to provide excellent light. These can also be moved in close to the subject for close inspection of minute plant parts.

When setting up lighting devices, always make sure the light comes from the left if you are right-handed, and from the right if you are left-handed, so that your hand does not cast its shadow across your work.

Containers

Containers of all shapes and sizes are necessary to hold the assorted paraphernalia that an artist accumulates. You will need glasses and jars to hold water; boxes for paints; and desktop arrangers for pencils, brushes, and erasers. Stationery and art supply stores carry plastic compartmentalized trays that will hold myriad small items, while a wide-mouthed jug or jar is probably the most convenient for brushes. Tubes of paint can be sorted by color and kept in small cardboard boxes; those in which the tubes are shipped can usually be had for the asking at art supply stores. These boxes can be kept all together in larger tin boxes like the kind used for cookies and candies.

Drawing Boards

Drawing boards are used as a support for paper. They are propped up in front of the artist so that both the drawing and the object being drawn, or painted, are seen from approximately the same angle. Art supply stores offer fine drawing boards of smooth wood to which paper can be attached at the corners with small strips of masking tape. Clipboards are handy and come in many sizes; the clips hold the paper in place. Inexpensive drawing boards can be made with a piece of Masonite or heavy cardboard and a few clothespins to hold the paper in place. Tabletop easels are available that will hold the drawing board up at an angle, but as a rule these are too high and clumsy for botanical artwork. I have found the most convenient prop to be a fairly thick book on which the board can be leaned, with the bottom of the board either resting on the tabletop or lowered to the artist's lap. This is a very flexible arrangement, since the board can be turned and tilted as needed, easily pushed closer to the subject matter, or pulled back. Do not work with the picture lying flat on the drawing table because this not only distorts the perspective in the drawing but unnecessarily pulls the muscles and ligaments of your neck, shoulders, and arms.

For a simple, versatile way of steadying a drawing board, try propping it up against a heavy book. The hand you do not use for drawing can hold the board firmly in place as you draw.

Pencils, Dividers, and Rulers

The "lead" of lead pencils is actually graphite, a soft black form of pure carbon, which is now made synthetically. Both lead and graphite were once used for drawing purposes, and the word "lead" came into casual use for either. As graphite became more popular, lead passed from use in pencils, but the name remains.

Drawing pencils are graded from 2H (moderately hard) to 8H (very hard) for hard leads, and 2B (moderately soft) to 8B (very soft) for soft leads. The harder the lead, the lighter the line. Hard leads are preferable for botanical illustration because delicate lines are wanted, and because the softer leads will smudge. It is a good idea to have several different grades of pencils on hand. Whereas 2H to 4H meet most of the drawing requirements, the very hard leads have a silvery quality that works beautifully for depicting white flowers.

Good drawing pencils are made under the trade names of Venus Drawing, Berol Turquoise, and Derwent Graphic by Rexel Cumberland, among others. The Derwent pencils go as high as 9H, and these produce a very fine, hard, light line.

Mechanical and technical drawing pencils can also be used for botanical illustration. They are available with leads in a range of diameters and hardnesses. These pencils have a consistent point, thereby eliminating the need for constant sharpening. Another advantage is that the lead can be retracted for protection while the pencil is carried.

Dividers and rulers are necessary to the botanical illustrator for obtaining accurate measurements of plant parts and distances between leaves, twigs, petals, and so on. The correct use of these helpful tools is described on page 43.

Erasers

Things have improved since the days of the poor Parisian models who ate the bread that artists used for erasing. However, bread still makes a good eraser that will remove light dust and smudges from paper. Crumble it and rub it across the paper very lightly. It causes no abrasion, does not remove pencil or watercolor, and can be used after a picture has been completed.

Plastic erasers (such as Mars-Plastic and Arttec) and rubber erasers (such as Pink Pearl) are fine for general use. Both kinds can be used for large areas or carved into sharp points with a paring knife for picking out tiny errors. They are nonabrasive and cause no damage to the paper. Kneaded erasers can be worked into whatever shape is required. Gum erasers do no harm to the paper, though they leave crumbs that need to be carefully removed.

The erasers found on the end of common writing pencils are likely to be too rough on the paper for overall use, but they can remove pencil lines in small areas.

Electric erasers can cause considerable damage to the paper unless they are handled with great skill and delicacy. They are probably best used on pen-and-ink illustration done on hard surfaces, such as plate-finish illustration board.

All erasers can be bought at art supply stores. You are likely to need a good supply and variety of them throughout your work on the picture. A large feather or soft-bristled brush will remove eraser crumbs from the paper and the entire drawing area.

Sharpeners

A sharp pencil is essential for drawing, so keep a sharpener handy while you work. Some artists use small sharpeners like those used by schoolchildren, but these will not produce a long, narrow point. For years artists have used penknives to whittle away the wood surrounding the lead, and then carefully shaved the lead with the knife to obtain a point. The lead may also be rubbed on small sheets of sandpaper that come in pads made for this purpose, called scratch pads.

Mechanical sharpeners fastened to a wall and turned by hand do a satisfactory job, and some of these can be screwed to a tabletop. Electric and battery-operated sharpeners are convenient and fast; both can be placed on your drawing table and used continually while you work without causing distraction.

Magnifying Glasses and Microscopes

To draw a plant accurately the artist must study and understand its structure in detail. It is important to know what the different plant parts are doing—how they connect with one another, where they spring from, and where they are going. This is why magnifying glasses are essential equipment. They allow the artist to examine the inner workings of a plant, as well as to see more clearly the external markings such as the dark spots on lily petals, the attachment of thorns to stems, and the veining in leaves.

The small folding glass, or jeweler's loupe, is useful in field work. (It is generally hung around the neck for convenience.) The standard library glass should be close at hand while the artist is working in the studio because it is used constantly. The magnifying, or library, glass comes in different sizes and can be bought inexpensively in stationery stores—or, for higher quality, at

Magnifying glass

Folding jeweler's loupe

Magnifying devices of several kinds are indispensable to the botanical illustrator.

stores dealing in binoculars, telescopes, and possibly cameras.

Microscopes are expensive and usually unnecessary unless the artist is doing highly technical work for scientific pub-

lications. But if the opportunity arises to use one, don't pass it up. A whole new world of fascinating and otherwise invisible parts can be seen—colorful, complex, and enlightening.

Gummed Tapes

A good tape for holding paper to the drawing board is masking tape, used in small pieces on the edges of the paper. Linen tape, available in art supply stores, is excellent for hinges used to hold pictures in mats. Clear or semitransparent adhesive tapes (such as

Scotch brand) should not be used at all with any kind of artwork. The adhesive used on these tapes can bleed through paper and canvas to leave a permanent stain, and removing the tape will destroy the surface of the paper to which it is attached.

Carrying Cases

Art supply stores have portfolios of different sizes for carrying pictures. Some, made of heavy cardboard, are open at the top and sides and held together by strings attached at the sides. These are relatively inexpensive but offer little protection to the contents. Zippered portfolios, many with interior pockets, can hold not only artwork but pencils, brushes, paints, and various types of paper.

Fishing tackle boxes will hold much that an artist needs, and variations of tackle boxes can be found at art supply stores. A cosmetic bag is exceptionally useful for tot-

ing artists' supplies. Paints kept in small boxes and paint trays fit neatly into the bottom of the case, while jars for erasers, penknives, and other small items can be held in place by the loops. A zippered top is preferable to the currently fashionable magnetic closing device, which can easily fly open. Leather-bound portfolios containing plastic envelopes held in loose-leaf fashion come in many sizes, are convenient to use, offer good protection for the artwork, and make a neat professional impression when the time comes to show work to an art director or dealer.

Paint Pans

Paint boxes containing cakes of color have mixing areas, usually in the lids. Of course, these colors can also be mixed in other containers, preferably white.

Paints in tubes are squeezed out onto paint pans. Porcelain containers with separate wells for holding the paint and for mixing purposes are convenient and come in a variety of shapes and sizes. White enamel-coated butcher's trays and white china plates make good palettes for paint, but since they do not have wells, the artist has to make sure the pure paints and mixed colors are kept apart. Plastic trays made for paints are inexpensive, lightweight, and easily portable; some come with covers. However, mixed paints are inclined to separate into bubbles on the plastic surface, so these trays are not as satisfactory for mixing large quantities of pigment.

There is no necessity to clean away the leftover paints that are squeezed from tubes. They will last for months and can be readily reactivated with water. When not being used, the paints should be covered for protection.

The best paint containers are made of porcelain with separate compartments for the paint, which is squeezed from tubes. The areas around the paint can be kept clean with a damp cloth so that colors won't become muddy. A small tube of paint will last for months.

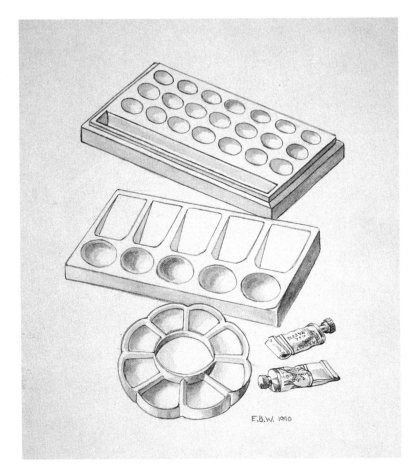

\mathcal{P}AINTS

As with brushes and paper, there should be no compromise with the quality of paints. It takes considerable time and effort to do a botanical illustration, and it would be a shame for inferior materials to mar the quality of the finished picture. The inexpensive colors that often come in small paint boxes rarely last well, nor are they of the quality required for fine watercolor painting. Student-grade paints are often considerably less expensive than artist-quality ones, but this is because they are made with different pigments that do not yield the same qualities of permanency or color mixing. Always buy the highest-quality watercolor pigments made by reputable firms.

Watercolors come in both tubes and small cakes. Many good watercolor boxes come furnished with removable cakes in individual containers that can be replaced when empty. Very little paint is required for a botanical picture, so tubes and cakes will last for months, if not for years. Both types can dry out: The paint in the cakes cracks and crumbles, and that in the tubes hardens. Paints in this condition should be discarded.

The caps of tubes very often stick firmly, and trying to twist them off may wrench open the side of the tube. The time-honored method of loosening a tight cap is to heat it with a match. This works well if the cap is metal, but caps made of plastic have an unfortunate tendency to melt into shapeless blobs. Using hot water to loosen tight caps usually works. Protect the labels with transparent tape.

PERMANENCY

\mathcal{P}ermanency refers to the lasting quality of a color—whether it can be relied on to retain its intensity over the years or whether it will fade within a few months. Other terms used to indicate color stability are "fugitive" and "non-fugitive," "lightfast" and "not lightfast." Art supply stores have color charts provided by different manufacturers that give a fairly accurate depiction of each color and indicate its degree of permanency. Permanency is usually graded on a scale from AA (a fast color) to C (a fugitive or fading color).

If you want your picture to last, buy and use only those paints with a B or higher rating. Not all of the most desirable colors come with a A or AA rating. If your work is being done strictly for commercial purposes where long life is not expected or required, any color that is suitable may be used. Regardless of the care that has gone into the choice of paints, no watercolor painting should be placed in a sunlit position or hung under fluorescent lights, because these will both drain away color. For tips on framing, see page 136.

THE COLOR WHEEL

*P*robably every schoolchild learns the colors of the rainbow: red, orange, yellow, green, blue, violet. A color wheel containing these colors and those in between (red-orange, yellow-orange, yellow-green, and so on) is convenient particularly for locating the opposite, or complement, of the color being used. Any color on the color wheel can be toned down by adding a little of its complement. Two complements mixed equally make a neutral gray.

Many books have been written on color covering color schemes, warm and cool colors, color combinations, and mixing qualities, to name just a few of the areas involved. Any artist is well advised to study color either with an instructor or by reading and experimenting.

The color wheel can be used as a quick reference. The neutral gray in the center of this color wheel was obtained by mixing complementary colors; the inner ring of colors shows each pure outer hue partially modified by adding a little of its complement.

Complementary color schemes use colors that are opposite on the wheel, such as red and green, or yellow-orange and blue-violet. Theoretically, if you mix any two complementary colors in equal amounts, you'll get neutral gray. (Obviously, if you mix lime green with mahogany red, you'll have to fuss a bit!)

Triads consist of any three colors equally spaced on the wheel, such as green, violet, and orange. Again, mixing all three in equal amounts will theoretically give you a neutral gray.

Analogous color schemes are made up of several colors that are adjacent to one another on the color wheel. Yellow-orange, yellow, and yellow-green form a three-color analogous scheme. Adding orange and green creates a five-color analogous scheme.

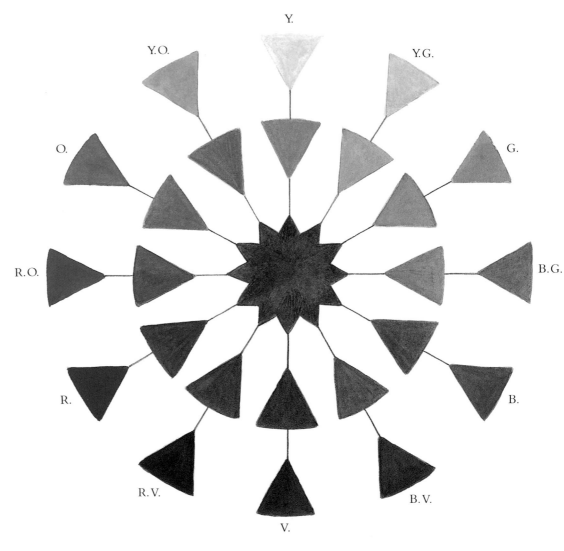

MIXING COLORS

*M*ixing and testing paint colors are important steps toward achieving the accuracy required in botanical illustration. Keep handy a small piece of the same type of paper on which you are painting in order to test your colors.

The pigments used in watercolors have different weights and varying mixing qualities. Some have a tendency to separate after being mixed together, the heavier pigments sinking and the lighter ones floating on top. All mixed colors should be stirred with the brush before they are applied to the picture. Your colors should match the actual plant parts as closely as possible.

It is important to know which colors result from mixing two or three pigments together. Again, this is basic color information. The three primary colors—red, blue, and yellow—are the only colors that cannot be obtained by mixing other colors together. The secondary colors are orange, green, and violet. Orange results from combining red and yellow, green from mixing yellow and blue, and violet from mixing red and blue. Obviously, the differences in the various reds, blues, and yellows will result in quite different tints and hues of the secondary colors. With the vast array of watercolor pigments on the market, the artist is not limited to just the three primary colors. But there are times when the exact color required can be quickly achieved by the sole use of them.

This is a start. It takes a lot of practice to fine-tune your sense of color so that you can accurately reproduce any delicate hue found in nature.

PAINT COLOR SELECTION

*T*he choice of colors and their manufacturers is a personal matter for each artist. Colors that are indigenous to given ecological areas, such as the Southwestern desert or the forests of the Northeast, will influence the selection for the painter's box. Here is a list of basic colors to which many more may be added.

Lemon yellow

Cadmium yellows (pale, medium, and dark)

Cadmium orange

Cadmium reds (light, medium, and dark)

Alizarin crimson

Carmine

Scarlet lake

Permanent rose

Permanent magenta

Cobalt blue

Permanent blue

Winsor blue

Ultramarine blue

Prussian blue

Winsor violet

Oxide of chromium (green)

Hooker's green dark

Burnt sienna

Raw sienna

Burnt umber

Indian red

Sepia

Raw umber

Chinese white

Designers white (gouache)

Pro White (gouache)

Some of the major manufacturers of fine watercolors are Grumbacher, Holbein, Schmincke, and Winsor & Newton. Some offer two grades of paints. For the highest-quality pigments and most permanent colors, purchase only the best grade of paints.

SPECIAL COLOR CHALLENGES FOR BOTANICAL ILLUSTRATORS

*B*ecause some colors present specific problems for botanical illustrators, they are taken up here individually.

Paint colors differ from one manufacturer to the next in quality and tone, so compile your own list of favorites. A personal color chart with swatches of color, names of manufacturers, and your comments regarding usefulness and workability is very helpful.

Green

The best greens are achieved by mixing blue and yellow together. The greens vary according to the blues and yellows used. Any pure, bright green can be toned down by the addition of a touch of red or one of the reddish browns, such as burnt sienna or Indian red. Since the greens differ from plant to plant, and even from plant part to plant part, the artist has to experiment with different colors to find the correct combination for accurate portrayal. Some greens in tubes and cakes are excellent and can be used in combination with the mixed greens. Sap green is a soft color that is extremely fugitive and should only be used, if at all, in a mixture with other colors. Oxide of chromium is a useful and stable color that can be combined with either yellow or blue to increase its range. Many other greens—including the Hooker's greens (light and dark), emerald green, viridian, ultramarine green, and Winsor green—have an almost "neon" brilliancy that should be toned down before use in botanical illustrations because they are brighter than the greens found in nature.

Lavender-Pink

Probably one of the most common colors found among flowers is the lavender-pink of petunias, wild geraniums, foxglove, and wild roses, to name a few. In its many variations from light to dark, it is a surprisingly difficult color to attain. Winsor & Newton's permanent magenta comes close, and it can be adjusted to the desired color with an overlay wash of blue or a red, such as alizarin crimson or permanent rose. The same permanent magenta mixed with Winsor violet produces a rich pink-purple. Keith West in his book *How to Draw Plants* states that no hue gives the botanical artist more problems than lavender-pink, which is sometimes called rose-purple.

> Cobalt violet, with a hint of carmine or alizarin, will reflect this handsome colour but it contains about the worst handling features of any pigment. It is muddily opaque and does not mix well with other hues. There are occasions when nothing else will do—but its use is kept to the very minimum. . . .

Cobalt violet has an oily texture and is also one of the most expensive of watercolors.

Yellow

The cadmium yellows, oranges, and reds are stable and dependable colors. One thing to remember about yellow is that pencil lines cannot be erased if covered by a coat of yellow paint, even if the yellow is pale enough to let the pencil lines show through. Therefore, if pencil lines are not intended to show in the finished picture, they should be erased to near invisibility before yellow paint is applied over them.

Blue

Many of the blue paints lean toward green. Winsor & Newton's permanent blue is a true blue that can be used as the base color for such flowers as the delphinium and the gentian. Cerulean blue, a clear light blue, can be difficult to handle because it has a tendency to "pebble" and will not go on in a smooth wash. It's still a good color for the botanical illustrator to have, and it mixes well with white.

Red

The cadmium reds, alizarin crimson, scarlet lake, permanent rose, and carmine are all essential reds for the watercolor palette. Holbein's watercolor line includes a rich, bright pink named opera, similar to the color known as shocking pink. It is not lightfast but artists should be aware that this brilliant color is available.

Black

A very good black can be mixed of reds, blues, and yellows. It takes a bit of fussing with the colors to get the proper degree and depth of blackness, but the color achieved is preferable to the manufactured lamp and ivory blacks, which are too intense and which muddy lighter colors when mixed. A simple way to mix black is by combining burnt umber with permanent blue. From these mixed blacks any number of grays and neutral colors can be obtained by dilution.

White

White watercolor is called body color, which means that it is opaque. When mixed with clear watercolors, it will make them opaque also. Paintings done entirely in opaque watercolor are called gouache paintings and require entirely different techniques from those described in this book. However, white paint can be used for highlighting parts of flowers, leaves, stems, and is particularly useful mixed with color for depicting hairs, thorns, stamens, leaf-veining and other minutiae of plant life. Designers gouache white, in a tube, and Pro White gouache, in a jar, are both good whites for the botanical illustrator to have on hand.

*B*RUSHES

Never compromise on the quality of your brushes. The finest hair for watercolor brushes comes from the tail of the male kolinsky (*Mustela sibirica*), a species of Russian mink. These brushes are advertised and sold as "kolinsky sable," and kolinsky sable rounds are the ones to buy for the purposes of botanical illustration. In the best brushes the hair is tapered to a fine point, swells out to form the "belly" of the brush, then tapers slightly back to the ferrule, the metal part of the handle that grips the hair. The artist should look for resiliency, or spring, in the hair, as well as sharpness of point and good water-holding capacity. No brush without these qualities, whether old or new, is worth using.

Many watercolorists have long considered Winsor and Newton's Series 7 brushes to be the best on the market, but there are other equally fine watercolor brushes such as those offered by Dick Blick, Daniel Smith (both mail-order houses with comprehensive catalogs), Grumbacher, and Isabey. The brushes manufactured by L. K. Hecht are composed of longer hair with considerable spring and are available through specialized art supply stores.

Brushes advertised as "sable" or "red sable," though good brushes and considerably less expensive, do not have the fine qualities of kolinsky hair. Brushes made of other animal hairs (such as squirrel or ox) and those made of synthetic fibers cannot achieve the desired effects required in a botanical illustration and are not recommended.

Here is a selection of kolinsky sable watercolor rounds. A good brush should hold a fine point and have resiliency when wet. Blunt brushes, brushes with loose hairs, and brushes that have lost their pliancy should not be used.

Brush sizes vary slightly from one manufacturer to the next. The "spotter" has shorter hairs than the regular brushes and is useful for very close, tight work.

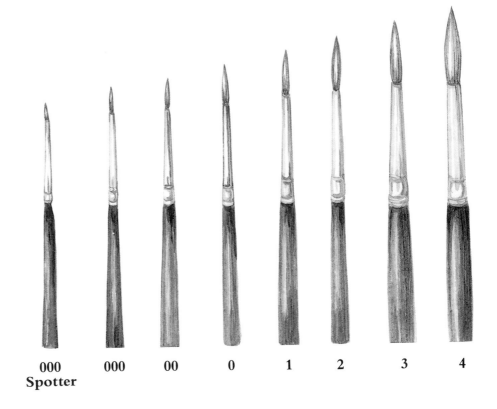

| 000 Spotter | 000 | 00 | 0 | 1 | 2 | 3 | 4 |

BRUSH SIZE

*B*otanical illustrations consist of small areas of color and often include very tiny lines to indicate hairs, stamens, and other flower parts. For this reason, brush sizes should range from 000 to 4. The size of a water-color brush is marked on the side of its handle. The most useful overall is probably size 2, but the smaller sizes are necessary for detail work.

A useful addition is a small brush with slightly shorter hairs, called a spotter or detailing brush, available in sizes ranging from 1 (the largest), 0, 00, and so on to 00000 (the smallest).

CARE OF BRUSHES

*N*ever leave a brush in water even for short periods of time, or leave a brush with paint on it. White paint is particularly destructive to brush fibers even though the brush is kept clean when not in use, so it is advisable to have one or two brushes set aside just for use with white in order to preserve the life of other good brushes.

Remove excess water from a brush by holding the hair against a paper towel or soft cloth. You can restore the point of a damp brush by gently stroking it with your fingers. Do not sharply slap a brush with a downward or backward motion, because this splays the hairs.

Brushstrokes should always move toward your painting hand, so that the brush hairs are pulled across the paper, not pushed against it. Pushing a brush against the paper forces the tip backward toward the ferrule; this will break and spread the hairs. Naturally this kind of treatment will drastically shorten the life of the brush.

When you transport brushes along with other painting supplies, protect them from damage by rolling them in stiff paper or by standing them upright in a narrow-necked container. A cosmetic bag with small side loops for holding jars makes a fine artist's carryall, with brushes stuck through the loops in upright position. A good kolinsky sable brush will last for years if properly cared for, and it is well worth the expense involved.

A very tiny brush will be needed to paint the slender stamens in the center of this magnolia blossom.

\mathcal{P}APER

Watercolor paper with a smooth surface and a small amount of tooth to it is best for close, carefully done watercolor illustration. Here is a list of some good papers for botanical illustrators. Try different kinds to find which ones best suit your needs and techniques.

Bristol paper, 2- or 3-ply, vellum finish is a good surface that takes watercolor well. This is not an expensive paper, so it is a good choice for beginning artists. It is also useful for experimentation in different watercolor techniques (such as new colors or brushwork) and for trying mixed media techniques (such as colored pencil and watercolor, colored inks, or watercolor and pencil). Vellum finish should not be confused with plate finish, since the latter is a smooth, glossy paper best suited for pen and ink.

Arches 140 lb. hot-pressed is a heavily sized, smooth-surfaced paper that is both durable and sensitive. It presents few problems and has a dependable consistency.

Arches 140 lb. cold-pressed has a slightly rougher surface than the hot-pressed paper. It has the same attributes as the hot-pressed and is one of the most popular watercolor papers. Both kinds of Arches paper are a trifle off-white, which bothers some artists. A French paper, Arches is available in most art supply stores and through mail-order houses. It comes in sheets 22 × 30″, which can be torn with a straight edge into smaller sheets. Arches also comes in watercolor blocks, with the sheets glued at the edges; the artist frees them with a penknife. There are also convenient portable pads of fifteen sheets in a number of sizes.

T. H. Saunders 140 lb. hot-pressed is on a par with Arches, though slightly more difficult to find. It is a smooth-surfaced paper made in Great Britain. It is also called T. H. Saunders Waterford.

Fabriano, an Italian company, makes fine watercolor paper with a slightly softer surface than the others listed.

Lanaquarelle is a popular French paper whiter in color than the Arches, though still having a slightly warm cast.

Strathmore, 2- and 3-ply, kid finish is a hard-surfaced paper suitable for close brushwork. It can be found in most art supply stores.

WEIGHTS OF PAPER

\mathcal{P}aper is graded by the weight of the ream, which consists of a quantity ranging from 480 sheets (20 quires) to 516 sheets (printer's ream). For our purposes a ream consists of 500 sheets. Thickness is an important requirement for a fine watercolor. A lightweight paper, such as 72 lb. or 90 lb., will buckle when water is applied. A 140 lb. paper is heavy enough to work well for general use. Heavier papers, 250 lb. to 400 lb., can take severe treatment, but because of the delicacy of botanical illustration, very heavy papers are not necessary. I use 140 lb. paper for most of my work.

STRETCHING PAPER

To stretch watercolor paper, the artist submerges the paper in water very briefly (20 to 30 seconds), lays it flat on a drawing board, and tapes the edges down with gummed brown paper tape, not masking tape. The paper shrinks and flattens as it dries so that it will not wrinkle or buckle when the watercolors are applied.

Because the areas to be painted in a botanical work are small, as compared to a watercolor landscape where the entire sheet may be dampened and readied for wet washes, stretching the paper is not necessary. Even when the artist lays down an initial wash of color on fairly large areas such as broad leaves, wide petals, or certain fruits and vegetables (see the eggplant on p. 89), the paper may ripple but it dries flat in moments, as long as you do not saturate the paper with too much water. Excess water may make the paper buckle and cause problems when you apply the paints.

RIGHT AND WRONG SIDE

Both sides of some papers provide a satisfactory surface for painting; bristol paper and the Strathmore papers are two examples. For determining the right side of other papers, hold them to the light so that the watermark can be read. The watermark is embedded in the paper when it is made and usually consists of the name of the manufacturer, sometimes with a trademark or other insignia. If you decide to tear the paper into smaller pieces, mark the right side in one corner on each piece, since the watermark appears on only one corner of the full-size sheet.

TRACING PAPER

Tracing paper comes in pads in a variety of sizes. It is inexpensive and has a particularly easy surface on which to draw. A whole plant can be drawn on tracing paper, or small parts can be done and transferred to a larger picture. (See pages 72–73 for more on transferring drawings.) Should a picture consist of a plant showing buds, blossoms, and fruits, all of which appear at different times of the growing season, the picture can be done in stages with tracing-paper drawings being laid over one another. Because the tracing paper is semitransparent, an entire picture can be designed by careful positioning of smaller drawings. And because tracing paper lends itself so well to depicting details, these initial drawings can be used for reference through the entire drawing and painting process. Tracings should be kept filed for future use.

Drawing Plants

POET'S NARCISSUS

PLANNING THE PICTURE

A good botanical illustration is an accurate scientific record of the artist's observations—and simultaneously a painting that is aesthetically pleasing to look at. To create such a painting, the artist must plan the picture carefully.

DESIGN

Any well-designed picture will lead the viewer's eye around so that it takes in the entire picture at a glance. If there is a center of interest, such as one spectacular blossom, the various components of the plant (such as stems and leaves) should lead the eye toward the blossom. When working on the initial drawings, stand back from the picture from time to time to sense where the eye is being led. Sharp angles that occur where plant parts meet can be softened by curving stems and leaf angles by just the smallest amount. Design can be enhanced by keeping background material very light so as not to intrude or distract from the center of interest.

These stylized depictions are examples of good design in botanical illustration. The viewer's eye goes around the picture, taking in the whole of the plant and being led to the main point of interest.

BOTANICAL ACCURACY

A botanical illustration must be a faithful reproduction of nature so that the viewer can identify the plant. There are no set rules that the artist must follow. To attain the required accuracy, the artist should study the plant (or portion of it being done) from all angles before starting to work. The artist must grasp its character, understand its structure (often with the aid of a magnifying glass), and decide on the most pleasing angle from which to paint it.

Leaves and petals can be adjusted within scientific reason to make a more agreeable arrangement; color can be heightened in the painting process if it gives a better indication of the plant's qualities. (For example, if the color of a very pale yellow flower is matched exactly in transparent watercolor, the painting will look more washed out than the flower itself.) One or more parts can be shown in a bisected view if they are of particular interest. Illustrations for scientific books and articles include all parts in detail, often enlarged.

Size is important. For the most part, the actual plant size is the most desirable. When a plant or its parts are either enlarged or reduced, indicate this on the picture.

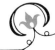

\mathscr{S}ETTING \mathscr{U}P

Plant material should be held in place as steadily as possible. Many tree and shrub branches are awkward to handle; flowers have a distracting ability to twist and turn, open or close, no matter how firmly fastened. Artists often have to use their ingenuity in devising whatever means they can to stabilize the material. Many commercial holding devices for flowers and branches are available through garden centers, florist shops, and mail-order houses that specialize in florists' supplies.

Florist's Foam

Sold under the brand names of Oasis and Filfast, this plastic foam is soaked in water and placed in a container. It will hold flower stems at whatever angle is desired but does not have enough holding power for thicker, heavier branches.

Needlepoint Holders

A needlepoint holder is a metal holder, generally round or oval, with sharp needlelike projections about an inch high into which the plant stems are thrust. They are available in many sizes and can be fastened firmly to the bottom of a container by strips of florist's clay. They provide a sturdy base for heavier branches.

Plastic Vials

Florists use plastic vials that hold water and have rubber caps with a small slit for inserting the stem of a flower. The vials can be fastened to a piece of cardboard with transparent tape, then propped up in front of the artist with the help of a couple of books, or held by a jig and clamp. The vial will keep a flower fresh while you paint it.

Soft Drink Containers

Probably the most easily obtainable holders for floral material are bottles with narrow necks. A stem can be further steadied with a wad of paper toweling stuffed into the bottle's neck beside the stem. Beer or soft drink cans also work well. Insert the flower stem into the opening, and then fold the pull-tab back against the stem to hold it in place.

Always remember, when setting up for botanical illustration, that the flowers and other plant material should be drawn and painted in natural positions. For example, a branch of flowering dogwood grows horizontally and should not be pictured growing upright. Positioning is important to make your subject look real.

Holding Jig

A holding jig with clamps (see the illustration on page 41) can be bought at hardware, radio, or electronic supply stores, or from catalogs specializing in hardware. Generally used to hold objects for gluing or soldering, the clamps can hold small branches at virtually any angle. Two items can be positioned at the same time. The plastic vials for water (mentioned above) will keep branches of flowers fresh.

Moving Flowers

All these methods—and many more are undoubtedly possible—are meant to hold flowers and plant material of any kind steadily in place. But there is nothing that can be done to prevent a flower, once in place, from turning toward the light, opening or closing its petals, drooping, or dying while the artist tries to capture it on paper.

Flowers bought at a florist shop have probably been kept under refrigeration so should be allowed a few hours at room temperature to open. Some may have been kept for several days at the florist's, and these may have no lasting qualities at all. Always ask the florist when the flowers in question were bought from the wholesalers and how long they will last. Many flowers bought in what appears to be tight bud will open out completely, then partially close, within a matter of hours. The only thing to do is wait until they have stabilized.

Most varieties of garden flowers picked early in the morning will last several days if they are in bud or just opened.

Botanical illustrators must work with the material at hand, setting it up as best they can, making their drawings as soon as possible and doing their paintings before the plant changes. Experience will teach the artist a great deal about what to expect and how to cope with the vagaries of the plant world.

A holding jig with clamps can hold woody vines, twigs, and small branches. Larger pieces that are top-heavy with leaves and fruit, or flowers with their cut ends in water, can be supported upright by the clamps. This device can also be used to hold white paper or cardboard behind plant material for visual assistance.

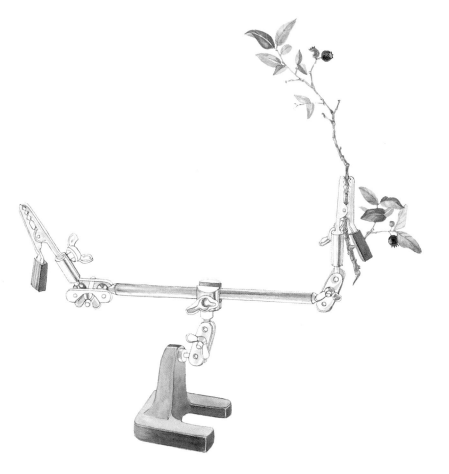

INITIAL DRAWINGS

Very few of us can use a brush with enough accuracy to do away with an initial pencil rendering. For this reason a careful drawing should be made of the plant or plant parts—whatever is the content—as the first step toward a finished picture. Methods vary from artist to artist; some work directly on the final picture from start to finish, while others do their basic work on tracing paper.

The tracing-paper method may seem tedious, but unless the artist is sure-handed and accurate, this method can save time and a lot of grief in the long run. Tracing paper is easy to work on and adaptable to changes; mistakes can be corrected in this stage so that a minimum of erasures need be made on the final picture. Using a hard pencil (2H to 6H), the artist can render a highly detailed drawing and use it for reference throughout the painting process, particularly if the plant changes form or dies before the picture is completed.

An accurate drawing of one flower with its stem and leaves may take anywhere from one to five hours to complete, though the amount of time required is really up to the individual artist, his or her degree of skill, and the type of plant being drawn. A double peony with its multiple petals will obviously take any artist longer than a single wild violet.

I can't speak for other artists, but it takes me approximately 15 hours to complete a botanical illustration. This includes making the initial drawing, transferring it to the watercolor paper, and doing the watercolor work. I usually work on a picture two to three hours a day, so that a picture takes me about a week altogether from start to finish. Certainly many kinds of flowers and leaves will wilt during a week's time, while tight buds will open into blooming flowers. This is why I find tracing-paper drawings invaluable as a record of how the plant looked when I *began* to draw it.

Some plants wilt so quickly once picked that there is no possibility of using them as models in the studio. Under these circumstances the artist can either press the plant in a flower press, or a book, and reconstruct it from its dried condition, or do sketches and quick watercolor studies on the spot for use later in the studio.

When making initial drawings on tracing paper, use as many sheets as necessary. The drawings can be laid over one another to give an idea of the final design of the picture, particularly if more than one flower and stem are to make up the whole. Individual areas can be corrected or redrawn with ease on small pieces of the tracing paper and inserted to replace the areas that need correction. The artist can also turn the tracings over to view the drawings in reverse, which makes errors in perspective become obvious. Any errors can then be corrected on the back. When the paper is turned to the front again, the changes made on the back show through, and the original inaccurate lines can be erased. Another method of checking for errors in drawing and perspective is simply to hold the picture up to a mirror which, again, reverses the image and shows up mistakes.

Many artists make marginal notations on their initial drawings, giving sizes, colors, shadow formations—whatever facts might be useful later. Information regarding the date and location where the plant was found, especially if it came from the wild, should also be recorded.

Once the drawing has been transferred to the watercolor paper (see pages 72–73), the artist can make further additions and alterations if necessary or desired. Again, a hard pencil is best because the graphite of softer pencils easily smudges.

Tracing-paper drawings as well as any other sketches may be filed away and used again for updated or newly created pictures.

BLOCKING OUT

A drawing is much easier to render if you start with an outline of its shapes and spatial relationships. Visualize and outline what you are about to draw without details, but as a series of interrelated circles, ovals, triangles—whatever shapes are there. Then, within that framework, mark the placement of flowers, leaves, stems, and other plant parts. Many a beginning botanical illustrator feels that, in order to save time, this step can be eliminated—but without the basic guidelines, the finished drawing can be seriously out of proportion and perspective. Constantly measure distances and angles as you work; even the outline will probably need refining.

MEASURING DISTANCES AND ANGLES

A straightedge and a divider are indispensable tools for the botanical illustrator. Correct angles and proportionate distances help the artist create an accurate drawing with correct perspective.

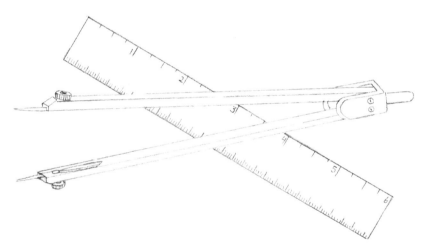

Dividers

A divider, probably one of the botanical illustrator's handiest devices, may be used to measure distances and ascertain angles. Hold the divider at arm's length and at right angles to the hand; don't point it at the plant. Adjust the tips to the size of the plant part as seen at arm's length, and then place the divider tips on the picture where the plant part is being drawn to give the correct size. Always use the divider at arm's length so that all parts of the plant will be in proportion.

Straightedges

Straightedges may be rulers (preferably small), pencils, or even pieces of cardboard. The direction in which plant parts grow can be very deceiving, and often an artist "knows" that a petal or leaf is turning downward but the actual drawing will require upward lines. When in doubt, hold the straightedge vertically or horizontally in front of the plant and turn it to match the line being drawn. Note well the angle of the straightedge, and draw the plant part to match. Even when you are absolutely sure of the direction of a line, checking it by this method avoids surprises.

DRAWING A

ℱLOWER

When drawing a flower, first look carefully at its shape. Is it oval, round, cone-shaped, or irregular? Study its stem, leaves, and general outline in order to understand its overall design and growth patterns. Turn the flower around to find its most pleasing and decorative aspects for illustration. Some of the most interesting views show the back of a flower, where its colors are usually paler and its sepals are visible.

Indicate the center of the flower with a small circle on the paper. A common error in drawing flowers is that of not placing the flower head correctly and squarely on the stem, with the result that the flower looks stiff-necked and disjointed. To avoid this problem, draw a light pencil line from the flower center through to the stem, and extend it upward through the blossom. Use this as a point of reference.

COMPOSITE FLOWERS

The composites make up one of the largest of flowering plant families and include asters, daisies, sunflowers, and dandelions, to name a few. A daisy is actually not one flower, but many dozens. The yellow part in the center, called the disk, is round and cushionlike in appearance, and it is composed of numerous tiny tubular florets. Each of the white "petals" that radiate from the disk is also a complete floret, called a ray flower. (But to avoid confusion, the following description will call them petals anyway.)

When drawing a composite flower, start with the center disk. Depending on the angle from which you are looking at it, the disk will appear as a circle or an oval. To avoid "losing your way" among the petals, mark one on the actual flower with a spot of paint to indicate your starting point.

Using a divider or straightedge, measure the distance from the center of the disk to the tip of a petal. Mark the distance on the paper, and draw a line from the disk to the tip to indicate the center line of the petal. (In the cases where the petals overlap, draw the front ones first and insert the back ones

later. Once the parts closest to you have been properly placed, those in back—such as leaves behind stems, or petals toward the back of a flower—will fall into place.) Again using the divider or straightedge, measure the distance and angle between the tip of the first petal and the tip of the next. Mark the spot with a dot to measure the distance from the disk, and note the center line of the petal. Proceed around the entire composite flower in this fashion, constantly measuring distances and checking angles.

The knowledge that each petal is about the same length as the next doesn't help when the flower, instead of facing you head-on, is turned away or pointing upward. The petals are greatly foreshortened. Here constant use of the measuring tools ensures accuracy.

Also note and indicate on the drawing the spiral pattern formed within the disk by the tiny tubular flowers in both bud and bloom. These flowers should not be depicted as just a series of random dots but should be very carefully delineated. They are an important botanical feature of the composite flower.

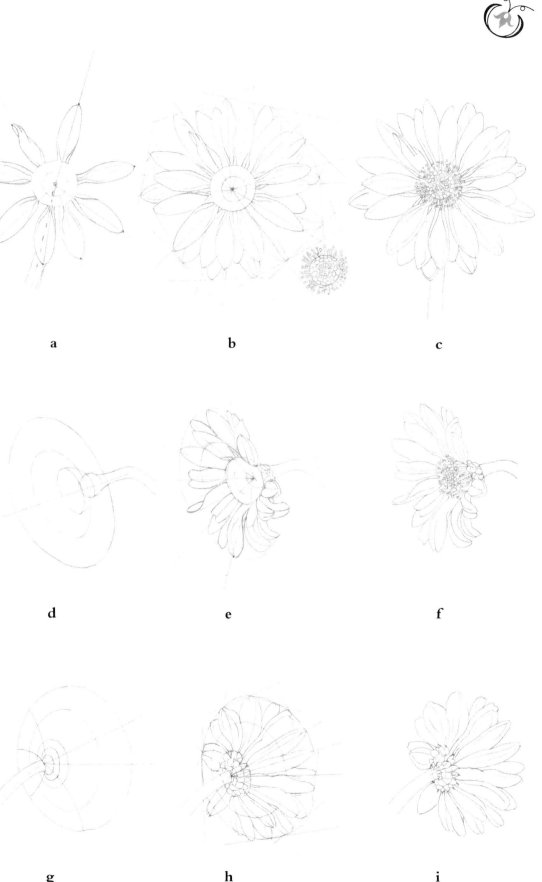

Here are tracing-paper drawings of a composite flower. In figure *a*, I drew the center dot and surrounding circles for the disk first. After measuring the length of the topmost petal with dividers, I drew a straight line up through the middle of the petal and then completed the petal around it. I then proceeded systematically around the flower, measuring the distance between the tip of each petal and the next one, and each petal's length from the center of the disk. The dotted line shows the center of the stem.

In figure *b*, the petals behind the original ones are added. I measured as many straight lines, distances, and angles as necessary to complete the circle of petals. Also shown here is the disk of the composite flower with its tiny florets, both opened and unopened. In figure *c*, the drawing is completed and ready for the addition of leaves and stem.

Figure *d* is a side view of the same flower with ovals as guidelines. Notice the straight line connecting the flower with its stem. In figure *e*, the length of each petal has been measured the same as with figures *a* and *b*. The petals on the right side are much foreshortened. In figure *f*, the center disk has been completed with its tiny flowers in place.

Figure *g* shows a back view starting with a series of ovals to indicate the spacing of the various sections. Both straight and curving lines emanate from the center dot to help place the petals. In figure *h*, the petals and circle of bracts are in place. Figure *i* shows the completed flower ready to be transferred to paper.

a

b

c

d

e

f

g

h

i

In this roughly blocked-out drawing, a lily is represented by circles and ovals that will help me place and draw the flowers and buds.

Some of the flowers and leaves are now in place. Above the larger sketch I have made careful sketches of the stamens and stigma of both opened blossoms for reference.

Tubular flowers can be drawn with a shape like a bowl or vase whose lines are lightly penciled to extend through the corolla. (The corolla is the collective name for the petals.) When drawing a flower such as a lily, do the inner petals first; then fit the outer ones (which in lilies are actually sepals) underneath and behind the inner ones. By the same token, when a lily is drawn from the back, the three outer petals become the predominant ones, so draw them first and fit the inner petals behind them. The petals are often recurved from the tube, and here a series of ovals can be drawn as guidelines for the artist. The daffodil with its nodding head, slightly recurved petals, and tubular center can be one of the most difficult flowers to draw. To correct errors in perspective, turn the drawing so that flower is pointing upward. Any bad drawing becomes obvious and corrections can be made.

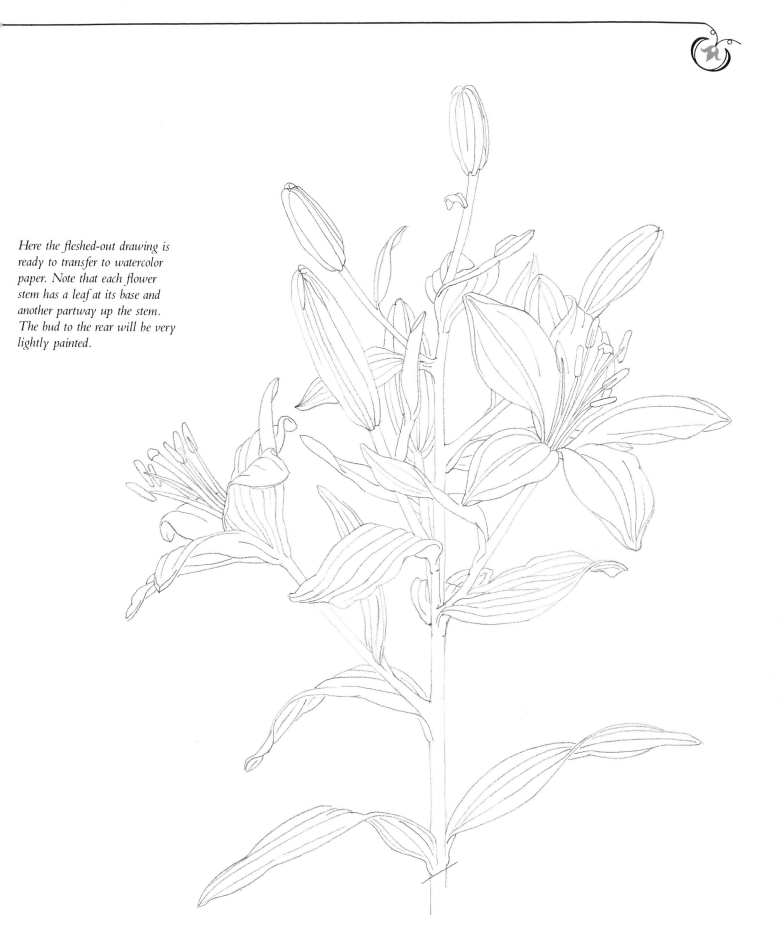

Here the fleshed-out drawing is ready to transfer to watercolor paper. Note that each flower stem has a leaf at its base and another partway up the stem. The bud to the rear will be very lightly painted.

Here are three successive stages
of a drawing of foxglove. First
the drawing is blocked out.
Then the blossoms are sketched
in place, with indications of leaf
placement. The final version is
ready to transfer; the blossoms
and leaves have been completed
in more detail and the original
guidelines have been erased.
Note how much the flowers
on this single stalk vary in
maturity, and how they are
turned at different angles so that
the perspective alters in each
case. Careful observation is
necessary to capture this effect;
the artist cannot simply draw
one blossom and then copy it
over and over.

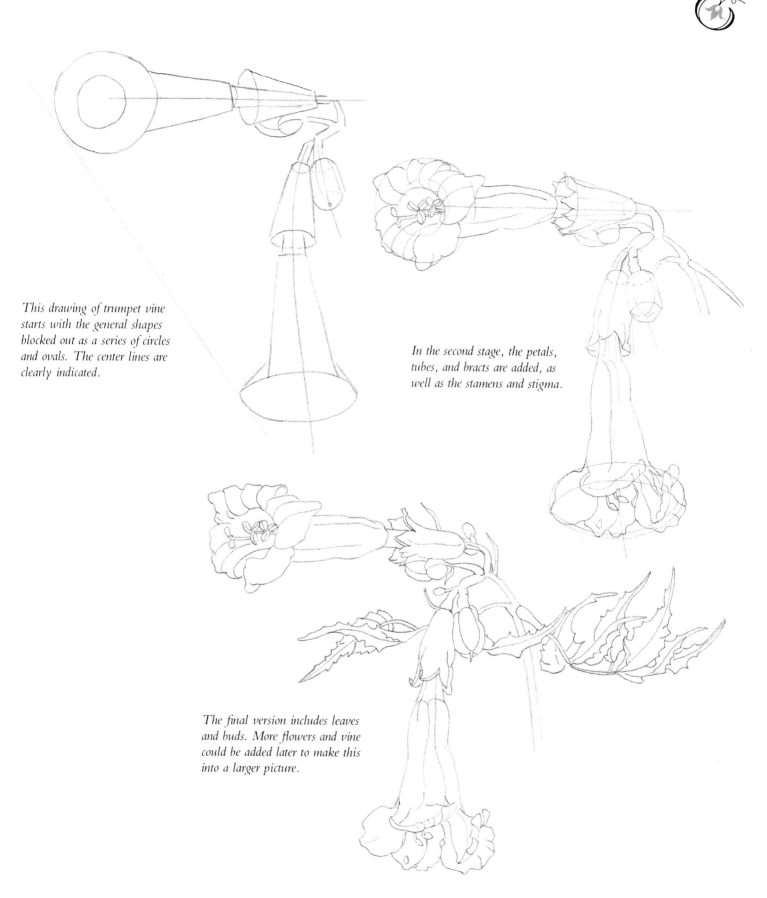

This drawing of trumpet vine
starts with the general shapes
blocked out as a series of circles
and ovals. The center lines are
clearly indicated.

In the second stage, the petals,
tubes, and bracts are added, as
well as the stamens and stigma.

The final version includes leaves
and buds. More flowers and vine
could be added later to make this
into a larger picture.

TEACUP-SHAPED FLOWERS

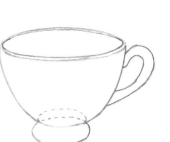
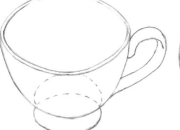
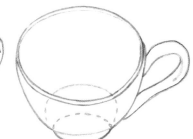

*A teacup is shown almost at eye level in figure **a**, tipped toward the viewer in figure **b**, and tipped even farther in figure **c**, showing the interior base.*

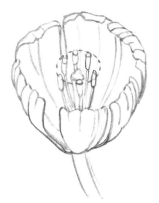

*Figures **d**, **e**, and **f** show a tulip in the same positions as the teacup. More of the interior becomes visible as the flower is turned.*

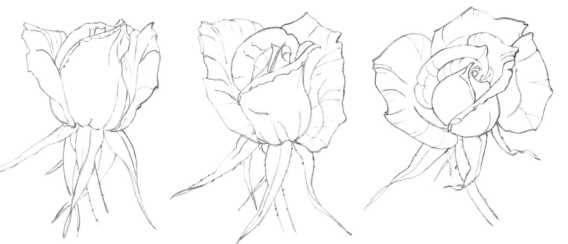

*Figures **g**, **h**, and **i** show a rose in the same positions as the cup. Many more of the petals are revealed as the rose is turned.*

A teacup can give the artist some idea of the perspective involved in drawing such flowers as roses and tulips. As the teacup is turned toward the viewer, more of the inside and bottom can be seen; with a flower, more of the center containing the pistil and stamens comes into view. If the flower is turned away from the viewer, more of the base of the corolla comes into view, where the petals attach to the pedicel. The teacup outline gives general guidance for the outline and interior of the flower, though not all parts will necessarily stay within this proscribed definition.

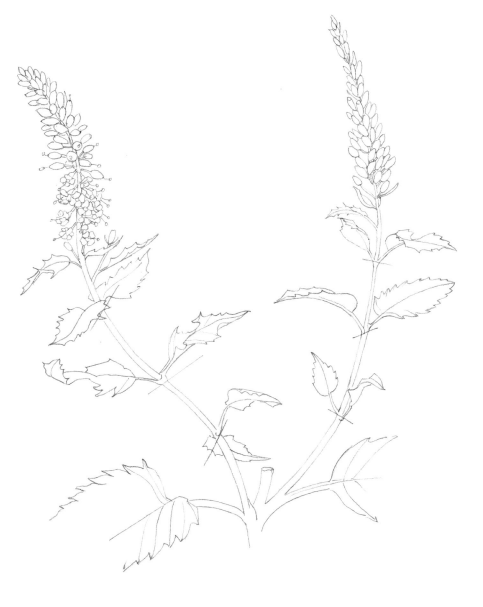

This blocked-out sketch provides useful guidelines for drawing the complex multiflowered blossom of veronica. Note that the opposite leaves rotate up the stem; it is important to depict such details accurately. In order to avoid a cluttered picture, I cut the center stalk short at the junction of the stems.

Individual florets are often grouped into clusters called inflorescences. There are several categories of inflorescences, including racemes, corymbs, umbels, cymes, and thyrses. (These names define further for the botanist how the florets are arranged and which ones mature first.)

In order to be accurate in drawing, probably the best way to discover the growth pattern is to take an individual inflorescence, or overall flower head, off its stem and carefully separate its parts, cutting it apart if necessary. The flowers of lilacs, butterfly bush, milkweed, and chokecherry, to name a few, present a fairly solid mass of tiny florets. The artist should observe how these are attached to their stems and how these stems are attached to the next larger. In the initial stages, a skeletal "stick" drawing to show the basic growth pattern and blocked exterior shapes is immensely helpful. Here again, it is important to locate the center stem from which all the smaller stems spring.

ORCHIDS

This drawing shows a slipper orchid blocked out. The sepal at the top was the starting point; I drew the center vein first, then the outside lines. From there, with the help of dividers and a ruler, I established distances and angles between the various parts.

\mathcal{S}ome flowers defy any surefire method of depiction. Certainly orchids, the largest of flowering plant families, rank high in this area. The orchid consists of an ovary, three sepals, two petals, a lip, and a column—but the shapes and sizes vary from one species to the next, from 1/16 inch to ten inches across. Scrutinize the flower carefully in order to analyze its varying shapes. A magnifying glass is almost imperative for the very smallest orchids.

The best way to start the drawing is with a perpendicular line, if this is a straight-on view, to indicate the center and transverse lines as guides to the petals and sepals. After these are in place, measure each part carefully, and one part against another—noting, for instance, if the petals are twice as long as the sepals. Measure distances between pairs of parts.

The orchid family has undoubtedly some of the most beautiful flowers in existence, coupled with some of the most awkward leaf structure. In drawing the whole plant, try to depict the leaves as gracefully as possible without losing accuracy. Let them contribute to the pleasing design of the picture as a whole.

Here the flower and leaves have been developed. Note the dark areas on the leaves, the tiny hairs and spots on the two lateral petals, and the tiny veins on the pouch. A number of leaves were eliminated at the base of the plant to give a clearer picture of the leaf construction and growth pattern.

HIDDEN FLOWERS

Some plants hide their flowers so that the most colorful and outstanding features to be painted are the areas around the flowering parts. The poinsettia's large, showy, petal-like red bracts in a flat rosette surround a cluster of small yellow flowers; the skunk cabbage has within its handsome bronze and green spathe a spadix, or spike, on which the tiny flowers bloom. When these important parts of a plant are too small or insignificant to show up well in a botanical watercolor, it is a good idea to show its details by drawing that part larger than actual size to the top, bottom, or side of the main picture. Note any increase in size. (For example, a depiction of a flower part that is twice as big as the actual part will have an ×2 before it.)

BACKS OF FLOWERS

The same principles of perspective apply to drawing the back of a flower as to the front. The center should be noted with a line drawn from the stem through the blossom. Also draw a series of ovals or circles to indicate the outer edges of the flower and the site of the pistil and stamens (or disk in a composite) even though in the finished picture these parts may not show. Make sure the stem is properly attached.

The back will show the receptacle of the flower which holds the seeds; attached to the receptacle are the sepals and bracts. The combined sepals form the calyx. When drawing a composite flower from the back, be careful to place the teeth of the calyx (that is, the pointed ends of the sepals) properly in relationship to the corolla (the ray flowers, or "petals"). Usually the teeth of the calyx point between the petals.

Buds, Stems, Leaves

Many artists are attracted to botanical subjects simply because of the beauty of the flowers. But no flower exists by itself floating in space. Flowers start with a bud formation that is attached to the plant in some manner. Stems are just as important as flowers and can be readily identified with particular plants, just as bark will identify a tree in midwinter. Leaves are also specific to individual plants, so the placement of veins, the type of serration (if any) on the edges, and the length, width, and color must all be drawn and painted carefully. A major portion of botanical illustration includes parts of plants that, at the outset, don't seem very interesting but that represent just as much of a challenge to skill and perception as the loveliest of blossoms.

BUDS

Buds and partially opened flowers, as well as blossoms past their prime, add interest and accuracy to a botanical illustration. Very often it is advisable to draw and paint the buds first, particularly those inclined to open rapidly. If an already opened flower is the starting point for the drawing, the buds may be in full bloom by the time the flower has been painted, so that their formation, lines, and color are lost to the artist. Daylilies can be particularly trying, for as the name implies, each blossom lasts only one day while the next day's flower is in bud ready to burst open.

One way to handle the problem is to make a rapid outline of the flowering head of the plant, noting where each blossom and bud is located, and then draw and paint a few of the buds at different angles to obtain their correct shapes and colors. Now that you have noted the placement of the opened flowers (which are probably already folding and drooping), draw and properly place *newly* opened flowers in these areas. This piecemeal method of putting the plant together works well and is a useful technique for many flowering plants that won't hold still.

Because the magnolia develops rapidly, particularly if brought indoors and forced, the buds on this branch were drawn first, transferred to paper, and painted. The blossom was done next and set in place on the paper, then painted. Finally I sketched in and painted the woody branch. I knew it would look the same long after the buds and flower had changed.

STEMS

Once you have drawn the flower in detail, it is important to pay the same attention to the stems. As noted before, the flowers must sit squarely on their stems. If the finished picture will be composed of several flowers and their stems, it is often necessary to draw the individual stems on separate pieces of tracing paper and then lay them over one another to achieve a pleasing design.

Remember that when a number of stems are present, they must connect with a leaf or flower unless deliberately cut short. Flowers floating apart from their stems are disconcerting, and stems drawn and painted at the base of a picture but leading to nothing have no meaning.

Stems can easily look stiff and graceless. A series of straight sticks marching across the paper are not attractive unless the overall design is highly stylized! Curve and arrange stems carefully, making some of them disappear behind flowers and foliage. In this way you can have them an important and integral part of the design that will help to lead the viewer's eye from one point to the next around the picture. Here a certain amount of artist's license can be justified as long as the stems are not distorted to a degree that is botanically impossible.

When multiple stems are part of the plant—as in a clump of creeping myrtle, or violets where the roots and stems are displayed—be extremely careful not to have three or more stems crossing one another at the same point. This can cause a "star" effect in the picture, which effectively attracts and stops the eye from going around the entire design. Carefully work out the lines of the stems before placing them on the final drawing.

Here is a badly arranged drawing of the crossing stems of creeping myrtle. Areas 1, 2, and 3 show too many stems crossing one another at the same point, creating a "star" effect that stops the viewer's eye from traveling around the picture. At area 4 the stems lack clear definition. The viewer has no way of knowing what part of the root system they come from. Area 5 shows a flower bract looking as if it were resting on or growing out of the wrong stem. Finally, the flower in area 6 could be growing atop a group of leaves, coming from either of two stems or attached to the leaf behind it.

This drawing shows the stems separated and coming from specific sites in the root system. The flowers are attached to individual stems, and the picture has a more decorative design.

LEAVES

*N*ote the placement and growth pattern of the leaves along the stem. Are they alternate, opposite, whorled, or spiral? It is important to reproduce this pattern faithfully. Draw lines indicating the midrib of each leaf in the direction it grows from the stem, and don't ignore the leaves growing from the back of the stem. Too many beginning artists are terrified to draw a leaf behind a stem, using as an excuse that it will ruin the picture, but if leaves are there, they should be shown.

Pay careful attention to the attachment of the leaves to the stem; some have stipules that look like tiny leaves at the petiole base. The petiole is the stalk to the leaf blade or to a compound leaf. Some leaves have long petioles, some clasp the stem, and some completely surround the stem. The attachment of the leaves can be very complex and colorful, giving the artist the opportunity to use bright oranges, reds, and yellows in some unexpected places.

The leaves of the herb lily (alstroemeria) have a characteristic twisting formation. This detail should not be overlooked, because it is an integral growth pattern of the plant.

Distinctive leaf patterns

Many leaves have such distinct veining that the plant family can be identified by this means alone, so the botanical illustrator must be accurate. Leaves of nearly all the monocotyledons (lilies, orchids, and irises, to name a few) have veins that start at the base and run parallel to the leaf edge, whereas the dicotyledons (roses, violets, geraniums, and the vast majority of flowers) have veins leading out from the midrib. Such leaves are often subdivided into a netlike pattern.

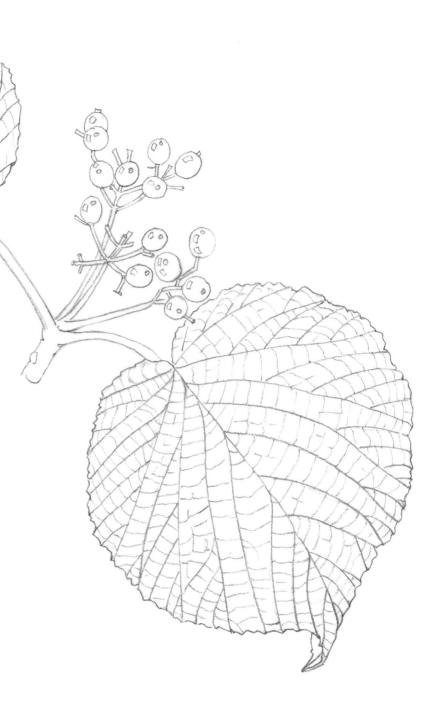

Look again at the multiveined leaves of the witch hobblebush, one of the viburnums. The veins indicate the way the leaf turns. I drew each leaf's center line first, followed by the carefully measured exterior line, then the deep veins leading from the center vein to the outside edge. Finally I put in the small crosswise lines indicating the wrinkled surface. Large leaves such as this take considerable time to paint, and a detailed drawing is immensely helpful. (See the finished painting partially based on this drawing on page 21.)

Midribs of a leaf

Often a leaf will curve in such a way that you see the top surface of part of it and the bottom surface of another part of it, usually the tip. To draw such a leaf, pretend that it is skeletonized or transparent. Draw the midrib as one continuous line that travels around the curve; this helps ensure correct perspective. Then draw in the veins and the rest of the leaf, always using the midrib as the central point from which measurements are made. The same foreshortening that applies to petals pertains to leaves seen at an angle. Again, the constant use of dividers and straightedges is advised.

In these drawings of the leaves of a tulip and an orchid, the thickness of the leaf is shown by keeping the nearside line of the leaf separate from the outside line. This discipline for depicting leaves also applies to petals and is extremely important for the proper delineation of these plant parts.

Thickness of a leaf

Drawing a leaf in perspective always involves indicating its thickness, no matter how thin or delicate the leaf may be. To show thickness, simply keep the near line of a curving leaf from touching the top line.

When painting the edge of a leaf, carefully delineate a line parallel to that edge with a small brush and light paint. Petals of flowers also should have thickness shown in the same manner.

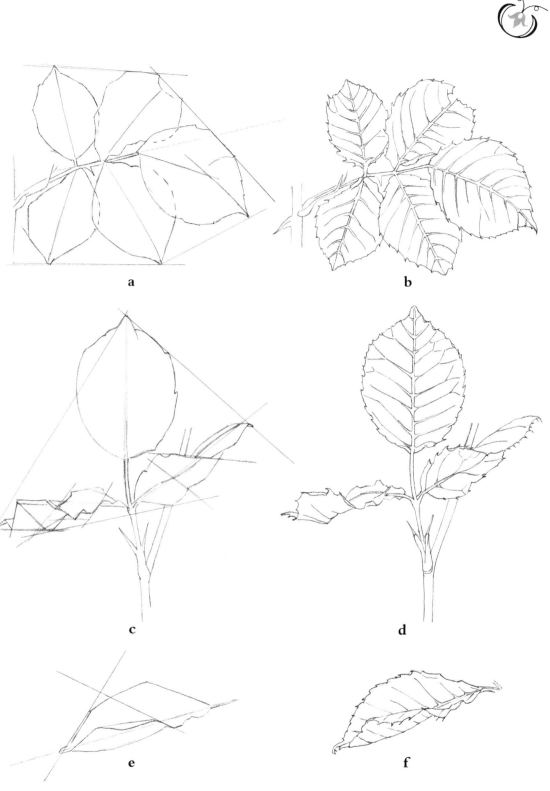

Figure **a** shows the compound leaf of a rose. The line of the stem was drawn first, followed by the center lines for each leaflet. Distances between the leaflets were measured by a divider, and the angles determined by a straightedge (in this case a six-inch ruler).

Figure **b** is the completed drawing, showing the serrated edge and veins carefully drawn from the midrib out to the edges.

Figure **c** is another view of a rose leaf with angled leaves. The shapes of the exposed portions of the lower and upper sides have been blocked out.

Figure **d**, the completed drawing, has veins in place and includes a careful rendition of the petiole and stem attachment.

Figure **e** is another blocked-out leaflet of a rose; figure f shows the finished drawing. As in figures c and d, the leaflet is curved so that both its lower and upper sides are visible in places.

a

b

c

d

e

f

Serrated leaves

If the leaf is serrated (that is, if it has sawlike notches on its edges), first draw an outline of the leaf without the serration. Indicate the center rib, and then draw in the serra-tions. When the veins of the leaf terminate at the points of the serrations, start the veins at the points and draw them toward the midrib rather than vice versa.

Excessive foliage

If there is a great deal of foliage on a plant, the artist must use discrimination in eliminating some of the leaves; otherwise the picture becomes cluttered. The eye of the viewer has difficulty not only in following the design, but in distinguishing the growth pattern when a cluster of leaves overlap and seemingly grow out of one another. Careful clipping to remove some of the leaves will thin out such a cluster and make it manageable. If it is necessary to indicate the number of leaves involved, for identification purposes or as being specific to that particular plant, some of the petioles or short cut-off stems can be shown lightly in pencil on the finished picture. If there are many leaves toward the back of the stem, some may be drawn and painted very lightly, others eliminated, to clarify the overall design of the picture.

Compound leaves

When drawing a compound leaf—that is, a leaf completely separated into two or more leaflets, such as that of a peony or rose—it is important to show the shape of the entire leaf and not just one leaflet. If the leaf is too large for the picture, you can do a small drawing of a whole leaf to one side, and then include only a leaflet or two on the full-size picture. But the whole leaf must show somewhere for botanical accuracy.

Large leaves

Some plants develop very large leaves after flowering. The small flowers of the bloodroot are wrapped in a leaf that continues to grow to about eight inches across after the plant has flowered. The early-blooming coltsfoot springs up ahead of its leaves, which then grow to a size that seems far out of proportion to the flower. In order not to overwhelm the flowering parts, these large leaves can be drawn in pencil or done in very pale washes of color behind the flower to indicate the size.

In this watercolor drawing of a violet plant, some of the leaves are merely outlined while others are treated in more detail. This prevents the leaves from completely overwhelming the delicate flowers.

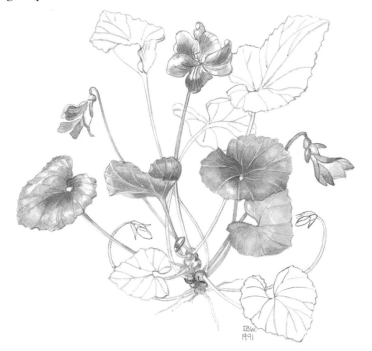

D R A W I N G
Fruits and Vegetables

Many books on basic drawing include instructions on drawing a ball with highlights, reflections, dark areas, low lights, and shadows. These are well worth studying before tackling an apple, orange, peach, or any other rounded object. Drawing fruits from many positions is a rewarding exercise; the time spent in doing a page of cherries will teach the artist much about drawing other types of berries.

The highlights on glossy fruits should be noted on the initial drawings. If you are drawing a cherry and the light is coming from the left and above, a bright highlight should show on the top left-hand side of the fruit. Fruits with less glossy surfaces will still have subtler highlights where the main source of light strikes them.

A low light would be cast on the right underside of the cherry just mentioned, caused by reflected light coming from below. A plant growing outdoors will have light reflected up from the ground, whereas a vase of flowers indoors will probably have a reflection from a tabletop. Naturally a polished wood tabletop will reflect more light than one covered with a black velvet cloth. The artist should observe and render low lights carefully. They will be lower in tone than highlights and help to indicate the texture and form of the object.

In drawing fruits and vegetables, just as in drawing flowers or leaves, the artist needs center lines, circles, and ovals to work from. Look for patterns because they will make your task easier. The growth pattern of a bunch of grapes can best be found by taking a small bunch apart to note the center stem line and the placement of the grapes and their stems along the main stem.

Spiraling diagonal patterns on such fruits as the pineapple are best worked out by drawing an oval approximating the shape of the object, with curving lines crossing one another indicating the directions of the fruit parts. This technique is also helpful when drawing pine cones and certain cactus plants.

Readily available when flowers are in short supply, members of the onion family present lovely colors and forms. The garlic clove shown here has carefully drawn roots. The large Spanish onion with its shiny skin has strong highlights on the top left and a low light reflection on the lower right. (For further development of these drawings into paintings, see pages 17 and 126–128.)

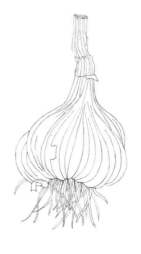

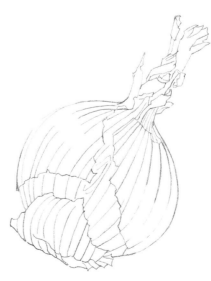

In figure **a**, the initial blocking for a pineapple shows the spaces into which the pineapple parts will fit. The individual sections of the pineapple have been sketched into place in figure **b**. Figure **c** shows the pineapple in more detail. The guiding diagonal lines have now been removed so that the details can be developed.

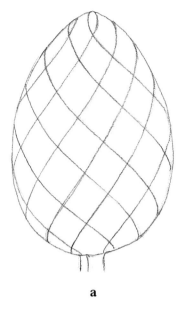

a

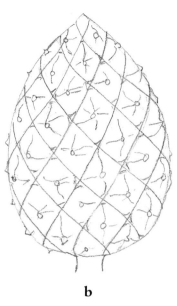

b

c

Figure **d** is the start of a drawing of an artichoke. Figure **e** shows the leaves of the artichoke sketched in, with their tops following the diagonal lines. Figure **f** is the completed drawing with additional details added. The artichoke is probably one of the easiest vegetables to draw.

d

e

f

SEEDS AND SEED PODS

*T*he seeds and pods of a plant should be given the same careful attention as the rest of the plant. The winged fruit (or samara) of the maples, the gossamer seeds of the milkweed and dandelions, and the curving seed pods of the trumpet vine and vetch all have decorative as well as botanical importance. A magnifying glass is essential for discerning the forms of some of the tiny seeds; do not just depict them as small dots.

WILD CUCUMBER POD
(Echinocystis lobata)
WATERCOLOR ON ARCHES 140 LB.
HOT-PRESSED PAPER,
1989, 7 × 8″ (18 × 20 CM).
COLLECTION OF THE ARTIST.

This wild cucumber pod was found in the late fall by a friend of mine who didn't know what it was and brought it to me for identification. The spiraling tendrils made a delicate design.

ℱLOWERING ℐHRUBS AND ℐREES

When drawing a branch from a tree or shrub (dogwoods, azaleas, and magnolias come to mind), begin by accurately planning the general outer shape of the overall piece, as well as indicating the main stem of the branch or branchlet and the placement of the flowers. It's probably easiest to draw the center line of the stem first; then place the flowers, leaves, and twigs as they lie in relationship to the center and to one another. The exterior lines of the piece will be refined as you do this. The tracing-paper drawing will gradually build up within the sketched lines.

Here I have roughly blocked out a small branch of flowering dogwood to obtain the general outline and placement of the parts.

The large bracts and leaves are now in place. The centers containing the tiny florets are shown in some detail for reference.

*The drawing of the dogwood is
now complete and ready to
transfer to watercolor paper.*

BULBS AND ROOTS

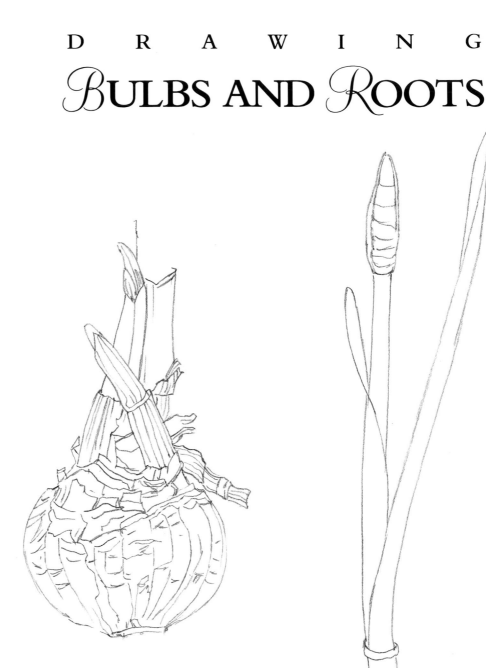

This bulb of a paperwhite narcissus was drawn before it was planted. It was just beginning to sprout. A few weeks after planting the bulb, I was able to add the first bud and leaves to the drawing.

Drawing bulbs is similar to drawing rounded fruits. Certain bulbs have outer layers of skin with an almost cellophane shine; such bulbs have bright highlights.

Plants such as paperwhite narcissus, amaryllis, and others used for indoor cultivation can be drawn piecemeal. First draw and paint the bulb with one or two emerging leaves. After the bulb has been planted in pebbles and water, add a few of the taller growing leaves. Later the stem, flower head, and some fully grown leaves can be added as the plant matures. When the flower has finished blooming, carefully remove the bulb from its growing material and clean the roots so that they too can be added to the picture. This process obviously takes several weeks, but the end result

The cluster of small white narcissus flowers includes a couple still in bud. Note that each flower has its own stemlet connecting the flower to the main stem. These should be carefully drawn.

After the blossom died, I removed the entire plant from the pot, gently shook the soil from the root system, and separated the roots with my fingers. The roots were carefully drawn to give form to each one and to keep them from looking like dangling strings at the base of the bulb. Many were omitted in order to keep their growth pattern and structure clear.

Turn to pages 122–125 to see how these drawings were developed step by step into a finished drawing.

is a picture of the entire plant throughout its growth cycle.

Long, threadlike root systems that spread out into surrounding soil should be clearly and definitively formed in a drawing. When drawing a complex multiple-root system, the artist again has to use discrimination in eliminating some. Several roots can be clearly shown toward the front while those in the back are lightly drawn, or, conversely, done in silhouette so that the ones in front show up against the dark ones in back.

As with plant stems, the design of the roots should be carefully worked out on tracing paper so that they don't form an incomprehensible mass of crossing lines but create a graceful design in themselves.

SPIRAL FORMATION

The spiral can be seen in virtually all types of plant life. Leaves spiral up a stem, and limbs spiral up the trunks of trees; the scales of pine cones spiral downward from top to bottom and the spiral formation is very obvious on pineapples, cacti, and artichokes. This is a basic formation in plant life that must be observed by the artist.

*The spiral is the underlying form for plant life. The spiral shown in figure **a** is then superimposed with a head-on view of the cone of a red pine in figure **b**. Figure **c** shows the cone without the guidelines of the spiral, but the spiral form is still perceptible.*

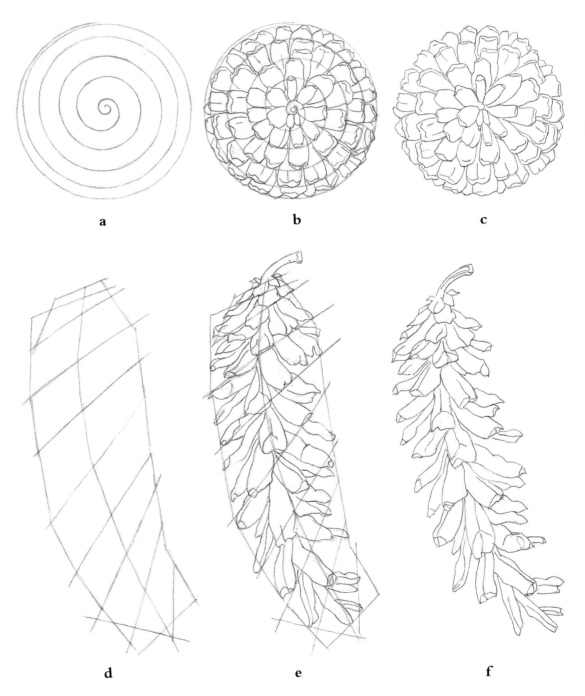

a

b

c

*In figure **d** the shape of the longer cone of a white pine has been blocked out. The cone is sketched into place in figure **e**, then finished in figure **f**.*

d

e

f

DETAILS

Small plant parts must be drawn with great care. Details often make the difference between an excellent botanical illustration and a mediocre one. The multiple florets in the disk of a daisy, the cushionlike center of the anemone, the circle of stamens in the wild rose, the long stamens and pistils of the lilies—all should be drawn accurately using a hard, sharp pencil. Thorns and hairs on stems and branches, "warts" on mushrooms, bundle scars on twigs, and the numbers of needles in a pine bundle must be accurate too.

Pay close attention to the various small lines, veins, and spots on flowers. These are not haphazard in design but have the ultimate aim of helping the plant reproduce.

Thus the rather sharp, strong lines on the two center petals of the alstroemeria point directly toward the center of the blossom; the series of brown "dots" that sprinkle the petals of lilies have a direction meant to lead some insect to the pollen; the tiny, dark pink veins on the pouch of the moccasin flower lead a bee to the center opening through which he enters to pollinate the flower.

Small details can be accidentally lost when you do the final painting, so refer back to your tracing-paper drawing to refresh your memory. It pays to make your tracing-paper drawings as detailed as possible, especially since you may use them for more than one picture.

These two anemones have carefully drawn details, such as the central cushion surrounded by stamens and the oddly shaped, fingerlike leaves.

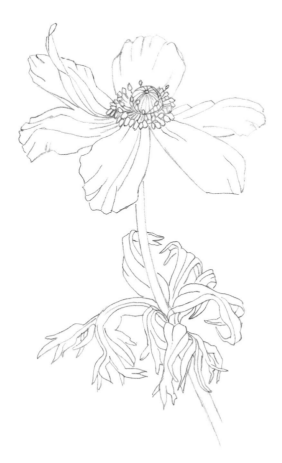

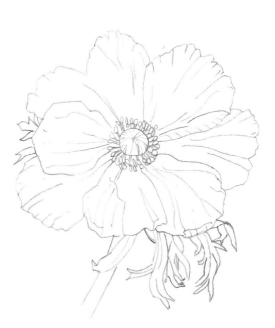

The stamens and stigma of this
daffodil are in place for reference
when the painting is being done.
Note also the careful delineation
of the edge of the flower's
tubular center.

This drawing of an alstroemeria
blossom shows the lines on the
two inner petals leading down
toward the interior of the bloom.

The samara, or seed, of the red
maple hangs from a twig and is
a pale pink when first seen
before blowing off in the wind.

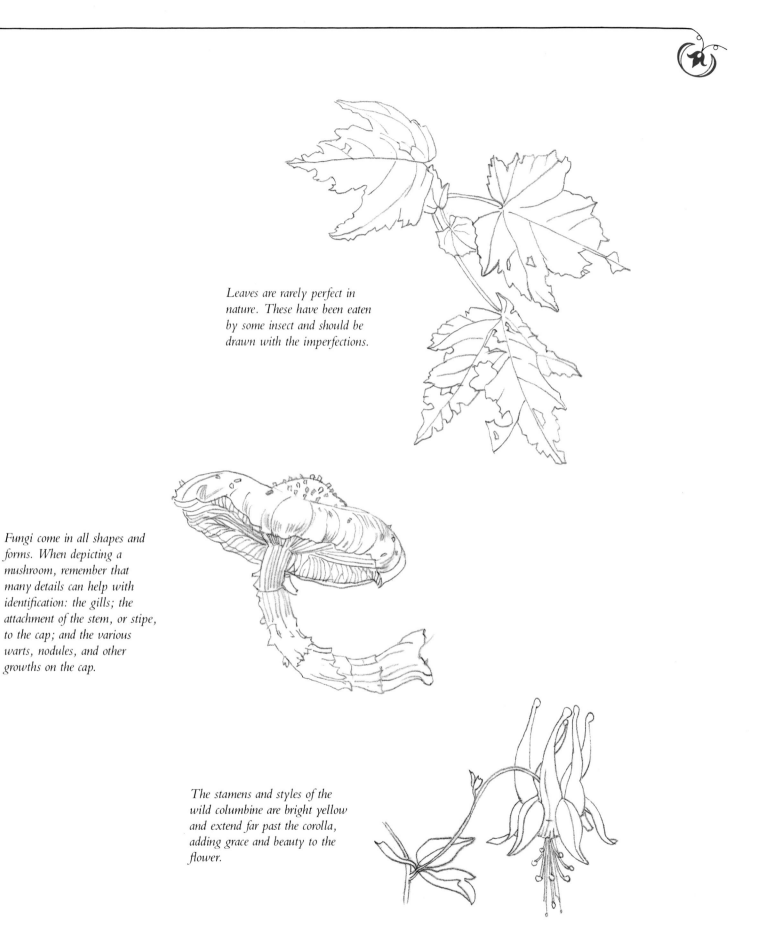

Leaves are rarely perfect in
nature. These have been eaten
by some insect and should be
drawn with the imperfections.

Fungi come in all shapes and
forms. When depicting a
mushroom, remember that
many details can help with
identification: the gills; the
attachment of the stem, or stipe,
to the cap; and the various
warts, nodules, and other
growths on the cap.

The stamens and styles of the
wild columbine are bright yellow
and extend far past the corolla,
adding grace and beauty to the
flower.

TRANSFERRING THE DRAWING

After you have completed a tracing-paper drawing to your satisfaction, you are ready to transfer it to the watercolor paper. The method most used over the years has been to turn the tracing-paper drawing face down and, on the back, go over the lines of the drawing with a relatively soft pencil; a 2H is satisfactory but do not use a softer one. When this is done, turn the tracing paper right side up, fasten it carefully to the watercolor paper, and again go over the lines of the drawing by pressing with a sharp pencil. The graphite just applied to the back will transfer to the paper beneath. By lifting the edge of the tracing paper from time to time, you can check for sections or details that you may have overlooked or that did not transfer properly, and draw them in. This may sound like a tedious process, but it actually takes very little time.

When a number of tiny plant parts are clustered together—such as the pistil and stamens in a flower center, small clusters of berries, or the flowering sections of dogwoods and poinsettias—the graphite can be applied in a thin layer over the back of the whole area using a rubbing motion with the pencil. When you turn the tracing paper to the right side, a sharp pencil going over the lines will transfer them to the paper. Because of the amount of graphite rubbed onto the back, be careful to avoid smudges, which you will have to erase from the watercolor paper.

The very light drawings that result from this method of transferring can be darkened with pencil. Corrections and alterations can be made if necessary, using the tracing-paper drawing and the plant material for reference.

Another simple way to make a transfer is to tape the tracing-paper drawing to a window, hold or tape the watercolor paper over it, and trace the lines that show through. Make sure the window is clean.

Very similar to the window method is the use of a light box. Tape the drawing to the glass surface and place the watercolor paper over it. Light projecting upward through the glass will show the lines of the drawing.

The ready-made graphite paper available in most art supply stores is *not* recommended for transferring. Used the same way a sheet of carbon paper is used with typewriter paper, the graphite paper unfortunately smears the paper beneath it, and the transferred lines are dark and cannot be erased.

Once the picture is transferred to the watercolor paper and you have made whatever corrections are needed, the picture is ready for painting.

The initial drawing of the cyclamen is completed on the tracing paper.

The tracing paper is turned over and each pencil line is gone over with a sharp pencil on the reverse side.

The tracing paper is again turned to the front and laid down on the watercolor paper. The lines of the drawing are again gone over with a sharp pencil with enough pressure so that the graphite just applied to the back transfers to the paper. This will make a very light impression that can be darkened with more pencil work; this is the stage you see in the illustration. Missing details can be added before the painting begins if necessary.

Watercolor

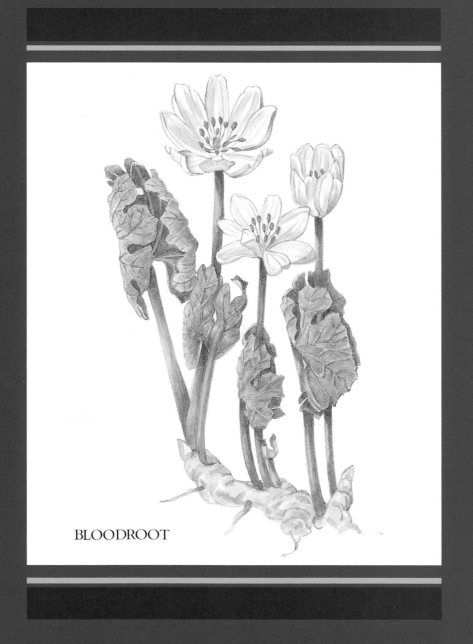

BLOODROOT

THE BOTANICAL ILLUSTRATOR'S
Medium of Choice

The botanical illustrator has a responsibility to be scientifically accurate in portraying plant life in its many varied forms. Absolute fidelity to nature is essential, including attention to the details that help to identify a given plant. The clasp of a leaf to a stem, the number of pistils and stamens in a flower, the growth habits of the plant—these and much more must be observed and rendered correctly.

Of utmost importance is exactness of color. Because flowering plants are inherently lovely to look at, it would be unthinkable not to paint them in the fullness of their beauty. Re-creating plants on paper is an irresistible challenge, and once the artist's eye has become accustomed to looking, many different tints and hues can be discerned.

Watercolor paints can be applied in delicate washes, one over the other. The clarity of watercolor lends itself to variations in color and a subtlety that is difficult to achieve in other mediums. Hundreds of colors are available that can be combined to attain a high degree of accuracy. Watercolor has a translucent quality capable of catching the lights and darks of the most ethereal blossoms, and yet it can be applied in deep, heavy colors to simulate the density of wood, the thickness of succulents, or the depth of shadows.

Once watercolor is mastered, it becomes the medium of choice for reproducing the beauties of nature in infinite detail. A fine botanical illustration done in watercolor can last for centuries and give pleasure to many viewers.

MISTAKES

One of the major myths surrounding watercolor is that mistakes cannot be corrected, that watercolor is an unforgiving, difficult medium and artists must either live with their mistakes or start over. Disasters, of course, can happen: a jar of water spilled across the paper, a blob of paint dropped on a white flower, when the only recourse is to start again. But, barring a catastrophe, most errors can be removed, corrected, or rendered unnoticeable. Never be afraid of errors or of making corrections, because much can be learned from coping with these problems. As you gain experience, you will make fewer mistakes.

Small drops of water that fall on the paper, particularly those with color, should be blotted up immediately with a paper towel, piece of blotting paper, or soft, absorbent cloth before the color has a chance to soak into the paper surface. If this fails, try scraping the spot carefully after it has dried with an X-Acto knife, mat knife, single-edged razor blade, or fine pen point (such as a crow-quill or a sharp-edged lettering pen), and then rub it gently with a

soft eraser. Trying to cover the spot with white paint is risky since the paint seldom matches the paper; a grayish mark is usually the result. A time-honored approach to small errors is simply to cover them with some portion of the plant—a leaf, flower, or bud—if it can be done without losing botanical accuracy.

If a mistake occurs in a painted area, lift out as much as possible with a clean brush dampened with clear water. Let the area dry. Mix the correct color using watercolor and water-soluble white paint, and then apply it carefully, blending it into the surrounding area. The offending mistake should be barely noticeable.

PROTECTING THE PAPER

Much can be done to keep the paper clean. Put a piece of paper, soft cloth, or paper towel under your painting hand to prevent natural skin oils from transferring to the paper. Oil on the surface of the paper will make the application of the paint extremely difficult. Another method is to cut a template of tracing paper to surround the part of the picture being painted, and rest your hand on that. Plastic bridges that span the paper and on which the hand can rest are available at art supply stores, but you will probably find that these are a bit cumbersome for this type of artwork.

Once you are set up with your watercolor paper, tracing-paper drawings, and the plant itself in front of you, a large jar for water at hand, paint trays with the proper colors, and brushes in a number of sizes, the painting can begin.

MIXING COLORS

Not all colors for the picture need be mixed at once, but enough of any one color should be mixed to accommodate all you will need for the entire picture. For instance, mix enough green for all the leaves, and note the different color components used to make this particular shade just in case the mixed color runs shy. If the mixed color dries in the paint pan, it can be readily reestablished by the addition of water. For more detailed information on mixing colors, refer to pages 30–33.

GENERAL PROCEDURE

Work on the picture as a whole, not one flower or leaf at a time. Apply initial washes of light color to leaves, stems, petals, and other plant parts; then build them up from there with additional color as the painting progresses. If you devote too much attention to the completion of·one petal or leaf at the beginning of the painting process, that one small section may become overworked and overemphasized to the detriment of the

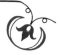

finished picture. However, when flowers are in full bloom and threatening to die shortly, complete them first and do the leaves and stems later. Buds should be painted early on because they will continue to open. Stamens, pistils, and other tiny plant parts can be very carefully delineated early in the painting process with a small brush so as not to be lost as the picture progresses. This approach means that any color adjustments to the rest of the flower must be painted around the details, which is challenging—but I find that this still works better than painting the details last, over several layers of petal color, which can create a muddy effect. After painting many different flowers, the artist will instinctively know what to do first.

INITIAL WASHES

First wet the area to be painted with clear water on a brush, and then apply very light color. Remember that watercolors are built from light to dark, that each layer of color will darken or intensify the ones already applied. Leave as many white areas as possible, wherever the light is striking. In this case "white" means the white of the paper, not white paint. These areas can always be darkened if necessary.

When color has been applied to the wet area, it can be moved around with a clean damp brush, lightened by being lifted out, or darkened by adding more color. The paper will stay wet for two or three minutes, during which the artist can add color and move it around. Too much water on the section being painted can cause the pigment to run toward the edges. In this case, pull the color back into the center with a fairly dry brush, and remove the excess moisture by blotting swiftly with a paper towel or piece of absorbent cloth. Because the types of paper recommended for this kind of painting have a hard, smooth surface (see page 36), colors will not run together or blur unless the paper is extremely wet. Allow the area to dry before adding another wash of color.

With each succeeding layer of paint the picture is developed. As the work progresses, stand back to see how it looks from about twenty feet away. The lights and darks begin to make an overall design, and you can make painting decisions about where light areas should remain, where dark areas should be strengthened, where shadows should be placed, and where improvements are needed. The actual plant should be used continuously as a model, since this is the best of reference material.

Final steps are the addition of the many details that not only sharpen up the picture but help to identify the specimen. The direction and placement of thorns and tiny hairs, the number of stamens, the color and direction of veining in petals and leaves should all be accurately depicted.

Many midribs of leaves are a pale yellow. These and the veins that extend to the outer edges of the leaf can be painted in after the leaf has been completed, using white paint with a touch of yellow. Water-soluble white paint has a different consistency from clear watercolor and should be applied fairly dry with a very fine brush. Great care should be taken that the paint doesn't spread into the surrounding areas, because it will dull the freshness of the watercolor. The first application may be absorbed into the paper to some degree, so a second application is necessary to make the veining stand out. The color in the veins in petals should be noted: darker pink in the mallows, darker purple in violets, for example. For these, no white paint is required.

LAYERING FOR SUBTLETIES OF COLOR

As artists become more proficient, their perception becomes more acute. A great many colors can be detected in each plant part. Pink flowers may have a bluish cast, lavender flowers a rosy tone; green leaves may tend toward the yellow or blue. When a plant part has been completely painted and has fully dried, a final application of a very delicate wash of the color that can just be perceived may be called for. This should be put on quickly and lightly so as not to disturb the layers of paint beneath. Try a small area first, so that you can stop if you don't like the resulting effect.

PAINTING WHITE FLOWERS

A question often asked is, "How do I paint a white flower on a piece of white paper?" Basically any white object on white paper is depicted by its shaded areas. Mix a very pale gray (blue and burnt umber combined). Study the white flower carefully to see where the shadows lie; then wash in the shadows with the pale gray, first dampening the area to be painted. After this initial wash has dried, darken the shaded areas as necessary with more washes of the same gray, smoothing the edges to eliminate hard lines. The exterior edges of the petals can be very faintly outlined with the brush point, either partially or completely around. A dark leaf or leaves can be placed behind the white flower in order to make it more visible, but the real challenge is to make the flower visible without resorting to a dark background. Note any colors that might be on the petals. Even though these are very faint, they will help to add form and interest. The interior sections of the flower can be made very dark, as well as the shadows on the unlit side of the flower, so that it gradually takes shape.

SHADING AND SHADOWS

Shadows give form and shape to the plant, so they should be carefully noted and accurately placed. Observe and carefully reproduce the shaded areas underneath leaves, under overlapping petals, on the side opposite the source of light, beneath crossing twigs and branches, and so on.

With the exception of white flowers, gray should not be used for shading and shadows because of the dull and lifeless look that results. By using the color of the plant part toned down with a small bit of its opposite color (see the color chart on page 30), the artist can create a deeper tone suitable for shadows. For example, the red petals of an amaryllis can be shaded by adding a touch of green to the red paint.

One of the earliest techniques devised for shading, actually dating back to the seventeenth century, is the use of delicately "drawn" lines done with an almost dry, sharp-pointed brush. These can create form on otherwise flat painted areas, the closeness and darkness of the finely painted lines

adding the required depth and darkness to the areas in shadow. These lines should be done very carefully paralleling one another (hatching). By adding lines going in a perpendicular direction, cross-hatching, the artist can achieve a very dark area. This watercolor technique is similar to the shading done in pen-and-ink work.

HIGHLIGHTS AND LOW LIGHTS

Highlights should be painted differently depending on the texture of the surface being painted. For example, the hard, shiny exterior of an eggplant with its rich, mahogany-purple skin will have a bright highlight best achieved by leaving the white of the paper, or by the use of white paint quite heavily applied after the rest of the painting has been completed. Since white paint applied to large areas looks flat and dulls the picture, it should be used sparingly. A peach with its fuzz-covered skin will have a much softer surface; in this case the highlight will not be in sharp contrast with the surrounding area but will consist of a light wash of color that becomes darker toward the edges, blending in with the rest of the peach's skin.

The same principles apply to low lights. Observe carefully what you are painting, and take into account the amount of reflected light, the color of the object, and its surface texture. Then reproduce what you see.

The trout lily is a small woodland plant common to the northeastern states. Its delicate flowers have yellow recurving petals, and its leaves are distinctively mottled in green and brown. To show the attributes of the plant, I enhanced the yellow color of the flowers and the mottling of the leaves.

TROUT LILY

(Erythronium americanum)

WATERCOLOR ON ARCHES
140 LB. HOT-PRESSED PAPER,
1984, 14 × 11″ (36 × 28 cm).
COLLECTION OF THE ARTIST.

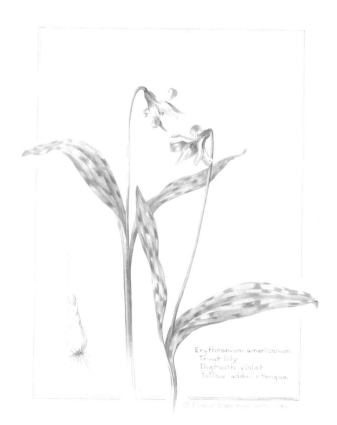

Fruits and Vegetables

Fruits and vegetables are a particularly satisfying alternative to flowering plants as picture material. One of the joys of working with them is their lack of movement.

An apple will sit still for a week; a winter squash lasts for months. A beet has beautiful color, but if leaves are involved in the picture, it's best to paint them first!

This dwarf blueberry had many small twigs, leaves, flowers, and fruits. It is easier to draw such plants directly on the watercolor paper rather than doing a tracing-paper rendition first. Faint pencil work defined the branch, and the picture was developed slowly, starting at the top left. A number of twigs and leaves had to be removed from the real branch, snipped off carefully with clippers, so that a clear representation would be shown. The flowering section was done in May, and the fruited portion was added in August. The wild blueberry leaves turn a rich, dark reddish brown in October; this color is indicated by the leaves on the right.

DWARF SWEET BLUEBERRY

(*Vaccinium angustifolium*)
WATERCOLOR ON T. H. SAUNDERS
WATERFORD 140 LB.
HOT-PRESSED PAPER,
1990, 11 × 9" (28 × 23 CM).
COLLECTION OF THE ARTIST.

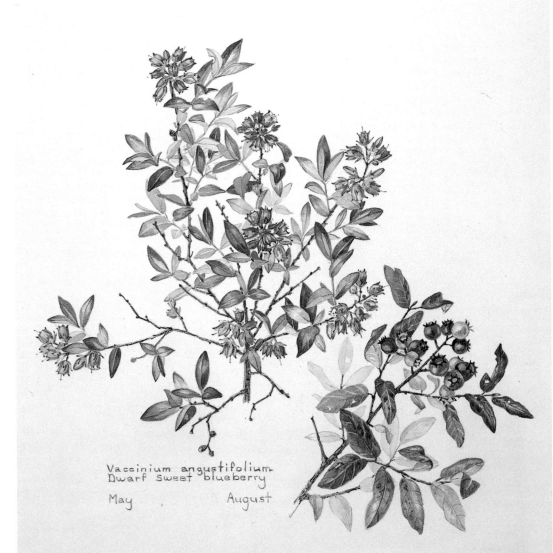

Vaccinium angustifolium
Dwarf sweet blueberry

May August

Eleanor B. Wunderlich 1990

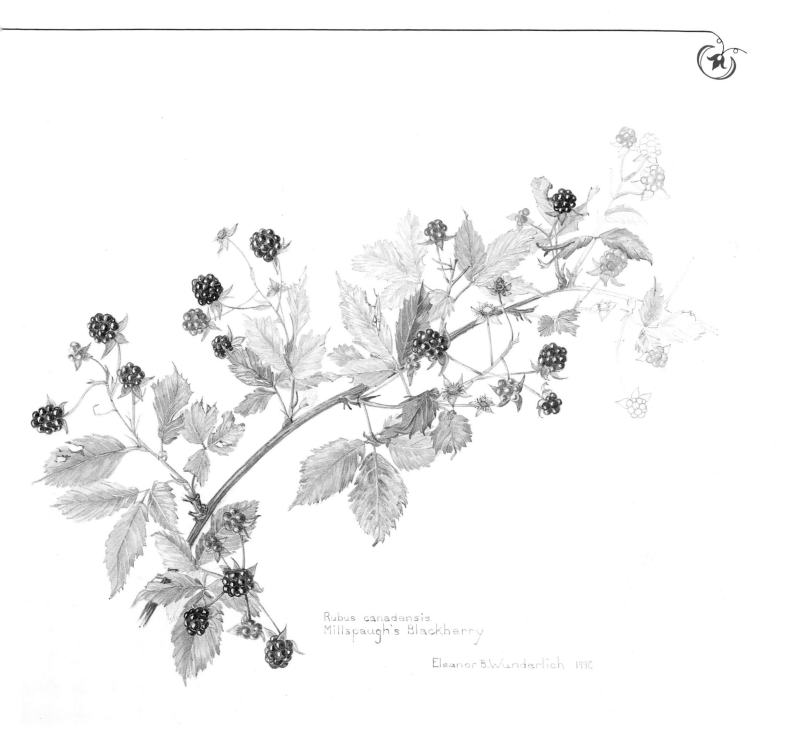

Rubus canadensis
Millspaugh's Blackberry

Eleanor B. Wunderlich 1990

Blackberries coming into fruit have a broad range of color, from yellows and reds to the very dark black of the ripe berries. This branch was approximately four feet long, so I painted only a small section of the central portion. The initial drawing was done directly on the paper starting at the lower left. The branch was held securely at one end by a needlepoint holder in water, while the other end was held aloft by a jig and clamp. As much color variation as possible was put into the leaves to add interest.

MILLSPAUGH'S BLACKBERRY

(*Rubus canadensis*)

WATERCOLOR ON ARCHES 140 LB.

HOT-PRESSED PAPER,

1990, 12½ × 11½" (32 × 29 CM).

COLLECTION OF THE ARTIST.

DEMONSTRATION: *Raspberries*

Wild raspberries abound in cut-over areas, serving as a ground cover and protection for slower-growing and more permanent plant growth. The fruits are rosy in color, sweet-smelling, and delicious.

Only a small branch was used for this depiction of the ripe berries. The tiny nodules had to be painted individually on a carefully done drawing in order to indicate the surface of the fruit. The branch bearing the fruit was carefully rendered, while in the background another was done in only the palest colors to add height and design and to indicate the rather scraggly plant growth.

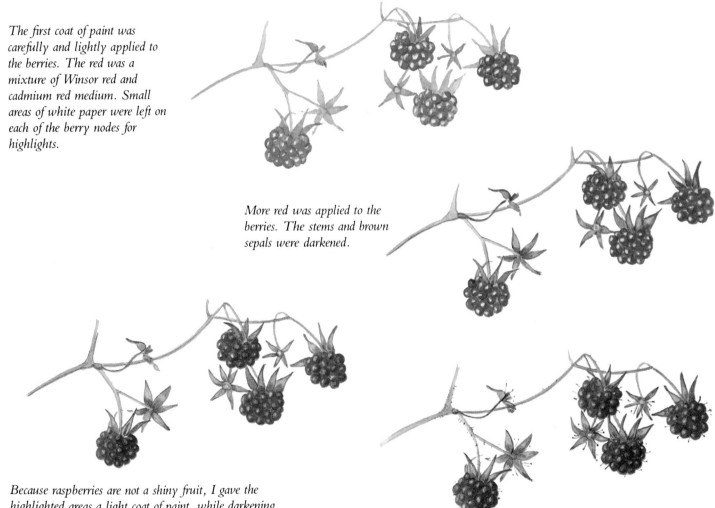

The first coat of paint was carefully and lightly applied to the berries. The red was a mixture of Winsor red and cadmium red medium. Small areas of white paper were left on each of the berry nodes for highlights.

More red was applied to the berries. The stems and brown sepals were darkened.

Because raspberries are not a shiny fruit, I gave the highlighted areas a light coat of paint, while darkening the right sides and bases of each of the nodes to give form to the fruit.

The final stage in developing the berries was further darkening at the bases with a mixture of red and burnt umber. The stamens were added as well as the tiny prickers on the stems. The berries received four coats of paint in all plus the last touches of dark paint. A number 00 brush was used for this work.

WILD RED RASPBERRY
(Rubus strigosus)
WATERCOLOR ON ARCHES
140 LB. HOT-PRESSED PAPER,
1989, 16 × 17" (41 × 43 CM).
COLLECTION OF THE ARTIST.

The finished picture of the raspberries depicts a woody branch with leaves and berries. Once everything was drawn on the paper, the berries were completed before the leaves were started. I completed the branch last because it would wilt long after everything else. Another leafy spray is shown in the background, painted faintly to give some dimension to the picture as a whole.

DEMONSTRATION: *Cherry*

*C*herries have a brilliant, shiny surface with a bright highlight. The problem here was to indicate the shine and also to pick up the different hues reflected on the cherry's skin, some almost black.

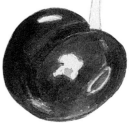

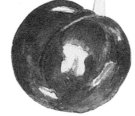

After drawing this sweet cherry, I dampened its image on the paper and applied a light wash of pink (scarlet lake and rose carthame). While this was still damp I added a touch of cadmium yellow on the right side. Areas of highlight were left dry and unpainted.

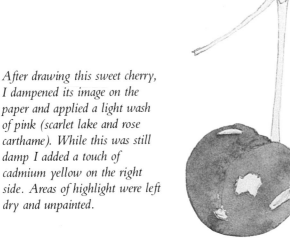

More of the same pink was applied to some of the areas where a darker color was needed.

Adding alizarin crimson further deepened and intensified the color.

The tip of the cherry and the scar on the right side are put in with dark gray. Green was applied to the stem.

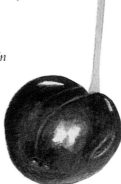

The finished cherry has one bright highlight on the top left; the other highlights have been softened by a pale addition of color. A slight mottling to the surface of the cherry skin on the lower right was done with alizarin crimson using a size 00 brush. Additional green was painted on the stem, and brown was added to its top.

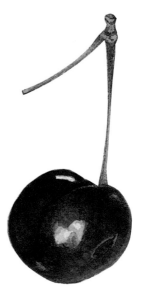

DEMONSTRATION: *Strawberry*

Strawberries have an interesting surface, slightly pitted for the seeds. The overall effect is of a shiny fruit, but each indentation has to be shadowed with highlights along the edges.

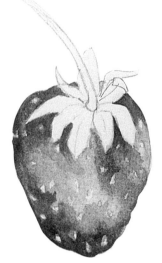

To paint this strawberry, first I dampened its area on the paper with clear water, being careful to leave the areas for the tiny seeds dry. I then applied a wash of color with a fairly wet brush around the outer edges of the fruit but lightened it toward the center.

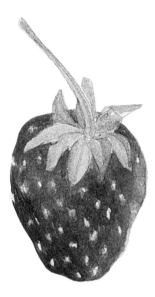

The red was deepened with another coat of paint, and a light coat of green was put on the stem and bracts.

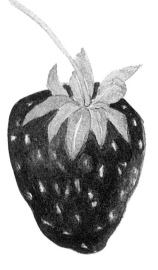

The fruit received a third coat of paint. By now I started to develop highlights and low lights.

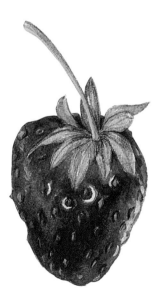

I gave form to the strawberry by lifting off some of the color on the underside and across the top of the fruit. Highlights done with white paint surround two of the dimpled recesses of the seeds. The seeds were painted in light brown and accented with dark brown. Adding a deeper green accented the stem and bracts.

DEMONSTRATION: *Artichoke*

A rtichoke leaves follow a geometrical pattern that is easy to see and draw. This vegetable is useful for its stylized design, reproduced on wallpapers and fabrics, but the purpose here was to show it realistically. Despite its flaws and browned spots, it is still an attractive and decorative item. This painting was done on an exceptionally heavy paper that resists buckling and wrinkling but requires heavier application of paint than the lighter-weight paper.

Once I had drawn the artichoke (see page 62 for a drawing of a similar one), I used a number 2 brush to paint an undercoat of pale green on the leaves of the artichoke. The green was a combination of permanent blue, cadmium yellow light, and a touch of burnt sienna. The leaves were first dampened, one at a time, with clear water before the color was washed on.

The leaves were darkened with another coat of the green, which was applied mostly to the bottom half of each leaf and to the shadowed areas. The second coat did not completely cover the undercoat.

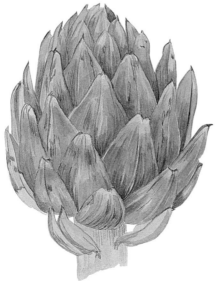

Again I applied more green to accent the dark areas. Touches of burnt umber bring out the sharp, pointed end of each leaf and indicate bruised or damaged areas of the vegetable.

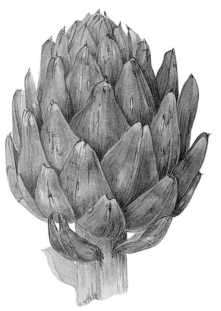

I continued working on the artichoke, further darkening the shadowed sections. More blue was added to the green on the right side, followed by a wash of light yellow carefully applied to some of the leaf sections. These subtle color variations enliven the overall picture.

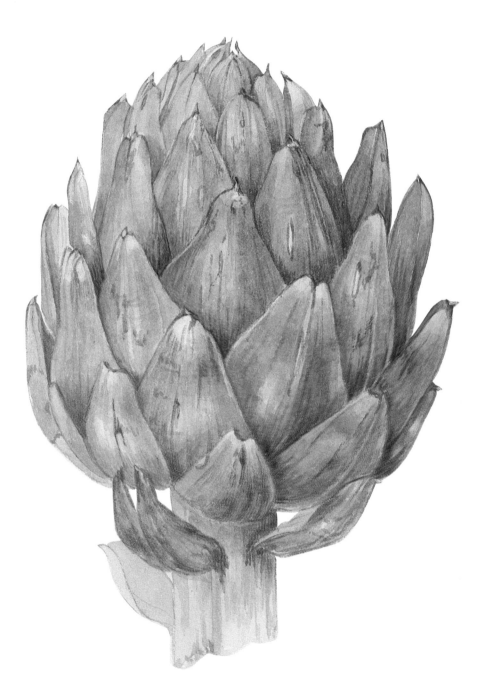

ARTICHOKE

(Cynara scolymus)

WATERCOLOR ON ARCHES 300 LB.

HOT-PRESSED PAPER,

1990, 8 × 6″ (20 × 15 CM).

PRIVATE COLLECTION.

DEMONSTRATION: *Eggplant*

*T*he eggplant is a fairly large vegetable with a very smooth, dark, shiny skin. The problem in painting it was to get the surface wet enough with clear water so that several layers of color could be applied before the paper dried.

Once the drawing of this eggplant was transferred to the watercolor paper, the area of the eggplant was completely dampened with water. I mixed enough color (Winsor violet and burnt umber combined) at the beginning to complete the painting of the vegetable. Some of this basic mixture was thinned with water to a light lavender, which constituted the first coat of paint. While the paper was still quite wet, I added more of the color to those areas not reflecting light from above, smoothing the edges of the additional layers to avoid harsh lines. Up to four layers of paint were applied to some areas before the paper dried.

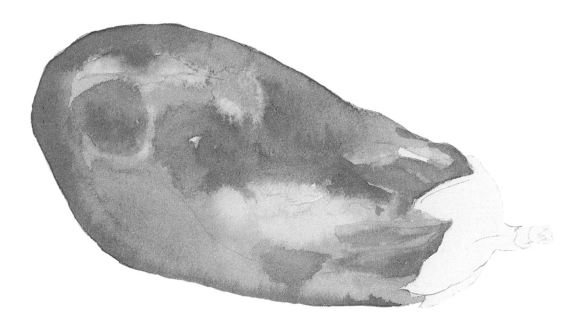

Once the painting was dry I added additional color, working the pigment around with the brush. The darkness built up slowly with each layer until I reached the desired degree of intensity. As a result the darkest sections have as many as seven layers of paint on them.

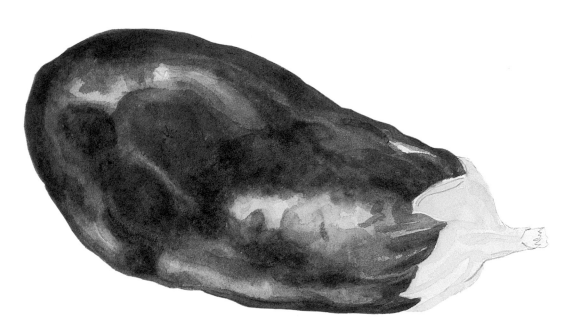

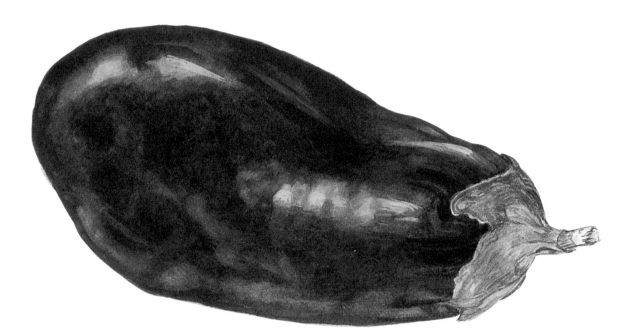

When the last layer of color was dry I used a clean, wet brush to remove some of the paint on the underside of the eggplant to create low lights, while a small amount of white paint accented the highlighted areas on the top. I used a number 3 brush for most of the painting, a number 2 brush to do the smoothing of any harsh lines that appeared, and a number 1 brush for the finishing work on the highlights and on the leaf and stem areas.

EGGPLANT

(Solanum melongena,
var. esculentum)
WATERCOLOR ON T. H. SAUNDERS
140 LB. HOT-PRESSED PAPER,
1990, 9 × 12" (23 × 30 CM).
COLLECTION OF THE ARTIST.

P A I N T I N G
*F*LOWERS

Trying to put into artwork the wonder of flowers has been the aim of artists for centuries. Working close to the subject, the artist finds that the flower seems to take on its own persona, becoming as well-known and familiar as a friend. Great pleasure and satisfaction is derived from the creation of a lovely floral portrait.

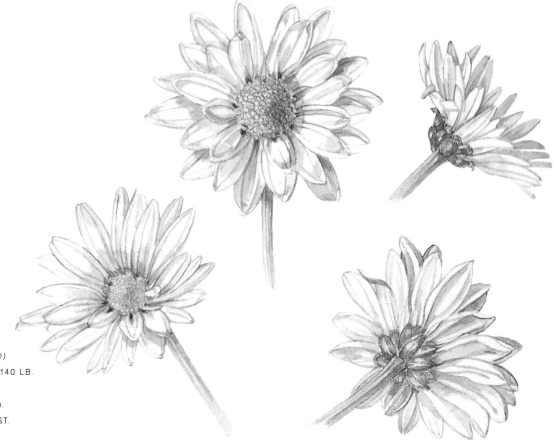

DAISY CHRYSANTHEMUM

(Chrysanthemum morifolium)

WATERCOLOR ON ARCHES 140 LB.

HOT-PRESSED PAPER,

1990, 14 × 12″ (36 × 30 CM).

COLLECTION OF THE ARTIST.

Four views of daisy chrysanthemums illustrate the blossoms from the front, back, side, and three-quarters view. In each case ovals and/or circles were drawn first on tracing paper to establish proper perspectives for the yellow disks in the centers and the white surrounding petals. (For more detail about the drawing process, refer back to page 45.)

After the drawings were completed and transferred to paper, I mixed a gray from permanent blue and burnt umber for outlining the petals and shadowing. Though petals are not usually outlined, it is often the only way to indicate white flowers against white paper. The centers were done in light yellow and then further developed with green. Shading on the right side gave the centers a rounded form.

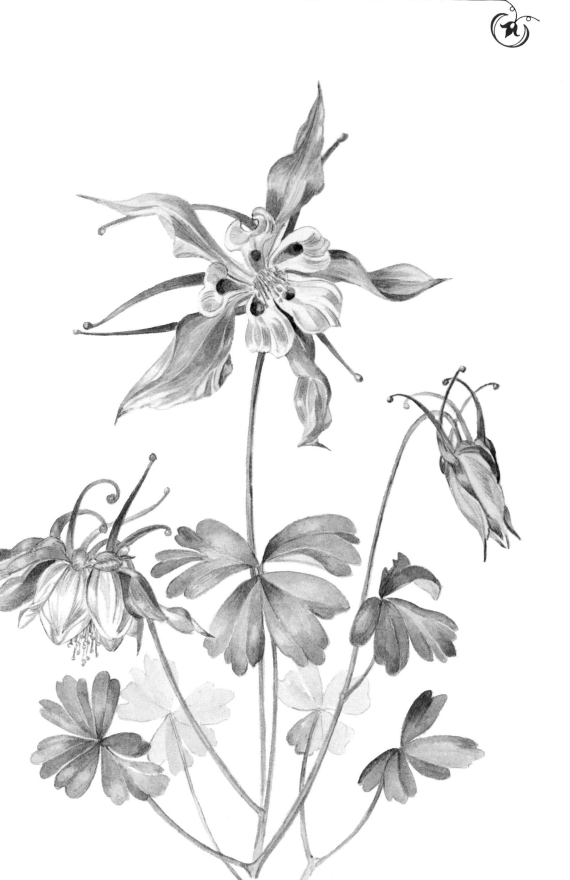

Small paintings can effectively show a plant's basic beauty. This view of the blue columbine is stylized in design, with the center blossom and stalk balanced by the two partially opened flowers on either side.

BLUE COLUMBINE
(Aquilegia coerulea)
WATERCOLOR ON
T. H. SAUNDERS WATERFORD
140 LB. HOT-PRESSED PAPER,
1990, 9 × 7″ (23 × 18 CM).
PRIVATE COLLECTION.

DEMONSTRATION: *Wild Columbine*

The wild columbine was drawn in bits and pieces: the flowers and buds first, then the leaves. I did several sketches of the leaves, and when satisfactory clusters were achieved, I "attached" them to the main stem. One group of leaves can be drawn from several different angles so that a lot of mileage can be had from a very small amount of plant.

Initial drawings of the delicate buds and flowers of the Eastern wild columbine were done on tracing paper, transferred to the watercolor paper, and painted before the buds opened and the flowers died in order to have the complete flowering sequence and to capture the correct colors. (I had previously done a quick pencil sketch to indicate the proper locations of all the parts.) The leaves and stems were to be added later. The red for the flowers consisted of a combination of cadmium red medium, Winsor red, and a small amount of alizarin crimson.

The stamens and styles were drawn with a hard, sharp pencil and then painted cadmium yellow light with a number 00 brush. Cadmium yellow medium was used to give more form to the stamens, and accents were added in pencil.

The plant was used as the living model even after the flowers were gone. The stems and leaves were added to the painting last. Because the leaves are a flat, unvarying color, more interest was given to them by varying the green with small amounts of either blue or yellow in different places. The basic green used for the leaves was a mixture of oxide of chromium with permanent blue and cadmium yellow light.

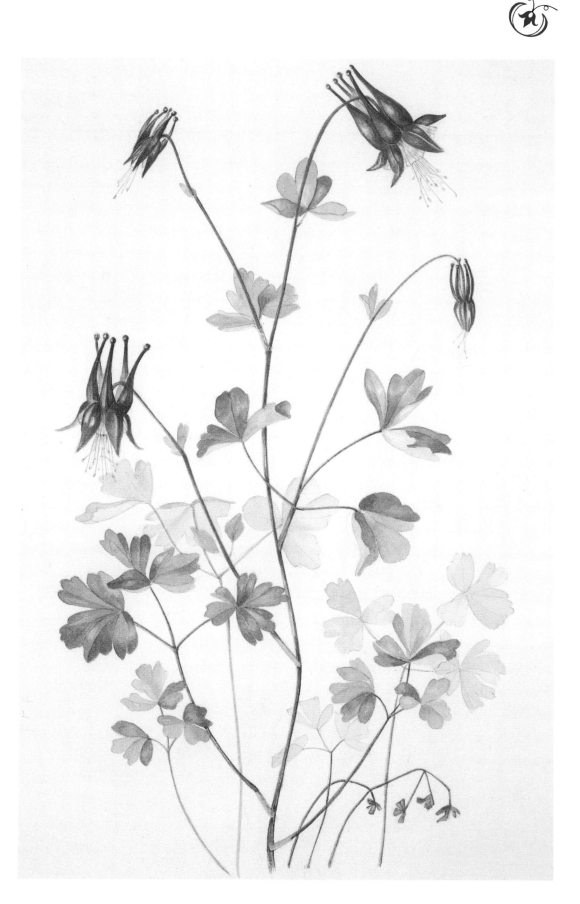

COLUMBINE

(Aquilegia canadensis)
WATERCOLOR ON
T. H. SAUNDERS 140 LB.
HOT-PRESSED PAPER,
1989, 13 × 10″ (33 × 25 CM).
COLLECTION OF THE ARTIST.

There are many species of goldenrod (Solidago), three of which are shown here. The drawing was done directly on the paper starting at the top of the center stalk. A light pencil line indicated the placement of the main stem, and I drew guidelines for each of the sprays of florets. The basic color was cadmium yellow light, darkened for the shaded areas with raw sienna. The clover in the foreground made a change in the overall yellow color scheme; I found it in a field growing adjacent to the goldenrod.

GOLDENROD

(Solidago spp.)
WATERCOLOR ON
T. H. SAUNDERS WATERFORD
140 LB. HOT-PRESSED PAPER,
1990, 14 × 11″ (36 × 28 CM).
PRIVATE COLLECTION.

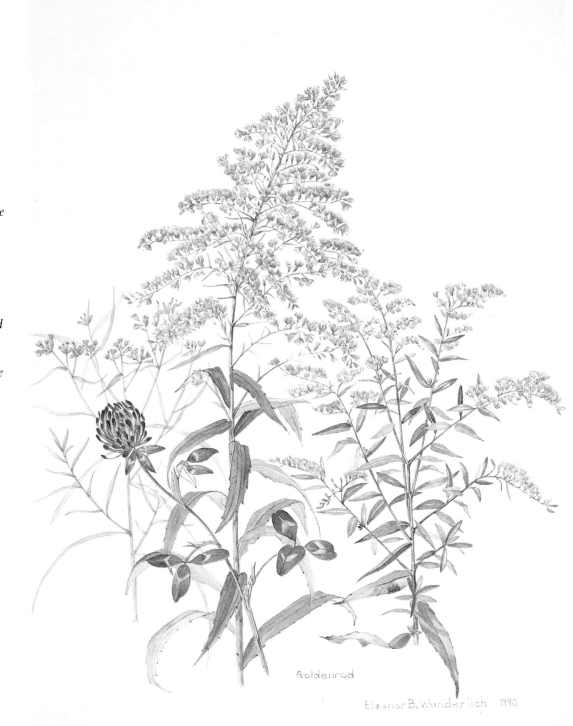

Goldenrod

Eleanor B. Wunderlich 1990

Many varieties of wild aster cover fields and roadsides in the fall months. I found this New England aster at the edge of a wooded area, with all its blossoms turned in one direction to face the sunlight.

Because the flowers don't last long after cutting, I drew and painted the plant in sections, working directly on the paper from the top down. As one piece died, I gathered a fresh one.

Each petal was carefully drawn because, with so many narrow petals on each flower, it would have been easy to make them look thin and stringy. I gave the petals a very light coat of violet and then darkened their outer edges and bases. The center disks were also drawn with care before the color was applied. Tiny touches of white at the tips of the stamens help them stand out.

NEW ENGLAND ASTER

(Aster novae-angliae)

WATERCOLOR ON ARCHES 140 LB.
HOT-PRESSED PAPER,
1990, 11 × 8" (28 × 20 CM).
COLLECTION OF THE ARTIST.

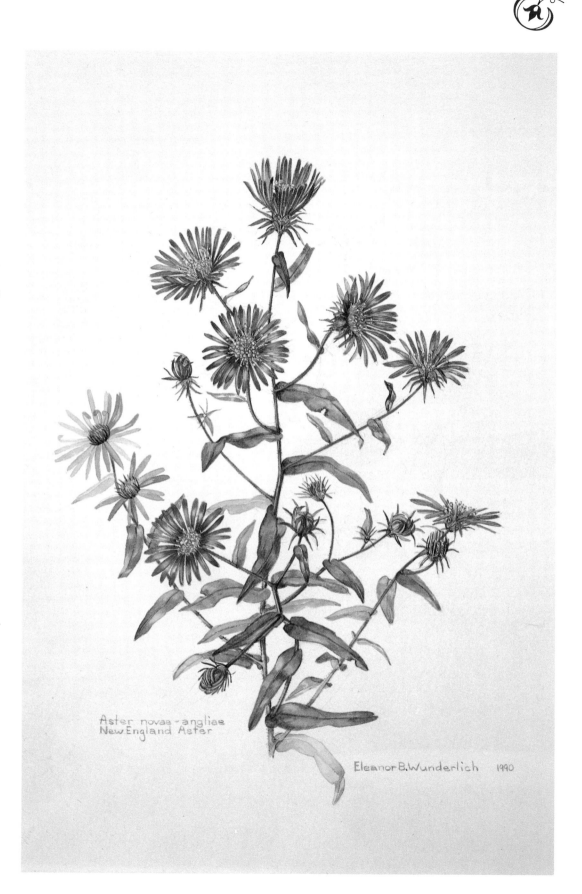

Aster novae-angliae
New England Aster

Eleanor B. Wunderlich 1990

DEMONSTRATION: *Yellow Goatsbeard*

*T*he goatsbeard grows in waste areas along roadsides, more often than not overlooked by passersby. It has an insignificant flower similar to the dandelion, but the seed head that forms later is a thing of beauty.

I made several attempts to draw and paint this "puffball" before I finally devised a technique that would convey its airy quality. A circle was drawn around a glass held upside down to the paper to attain the outside circumference. (Use of a drawing compass would have resulted in a hole in the paper.) After the correct size for each of the seed "parasols" was established, they were traced around the center: three different rows with three different angles of view.

The airy seed head of the yellow goatsbeard is similar to the familiar dandelion puffball but approximately five inches across. It is the showiest part of the plant. Each individual seed has a calyx of fine hairlike plumes that act as a parachute when the seed is blown free from the flower. If sprayed with clear acrylic spray the seed heads will hold their shape and last for months. Three drawings were done of tiny seeds with their "parachutes": (a) nearly from the front, (b) partially turned away, and (c) from the side.

a b c

I drew a circle on the paper to define the outside perimeter of the puffball. (A large water glass was used instead of a compass, which would have left a hole in the paper.) The drawings of the individual "parachutes" were traced into place circling the center. The near-frontal views are closest to the center, then comes a row of those slightly turned away; the outer row shows the side view.

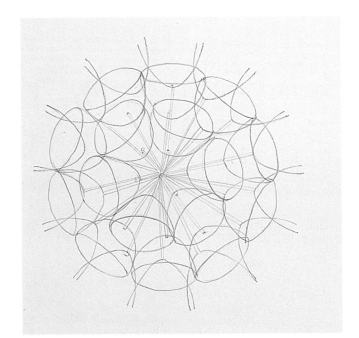

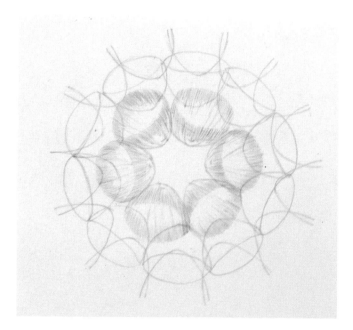

The tiny hairs on the innermost layer were painted a very pale gray using a number 000 brush.

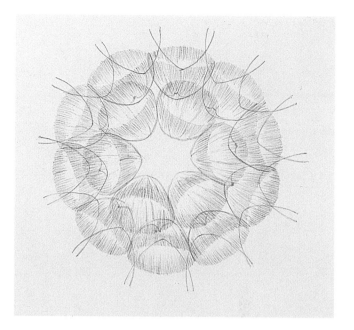

The second layer of seeds was done the same way, in some areas overpainting the work done on the inner layer.

Here I painted the outside layer of tiny hairs and drew the delicate, narrow stems leading to the center.

The stems were painted a pale brown darkened on the sides to create a rounded form. Some pale brown was added to the gray of the seed plumes. For a bit more color, a touch of light red was also added to the stems and seeds.

The finished picture shows the different stages of the plant's development, from yellow flower to puffball to the dispersal of the seeds.

YELLOW GOATSBEARD

(Tragopogon pratensis)

WATERCOLOR ON
T. H. SAUNDERS WATERFORD
140 LB. HOT-PRESSED PAPER,
1990, 15 × 13″ (38 × 33 CM).
COLLECTION OF THE ARTIST.

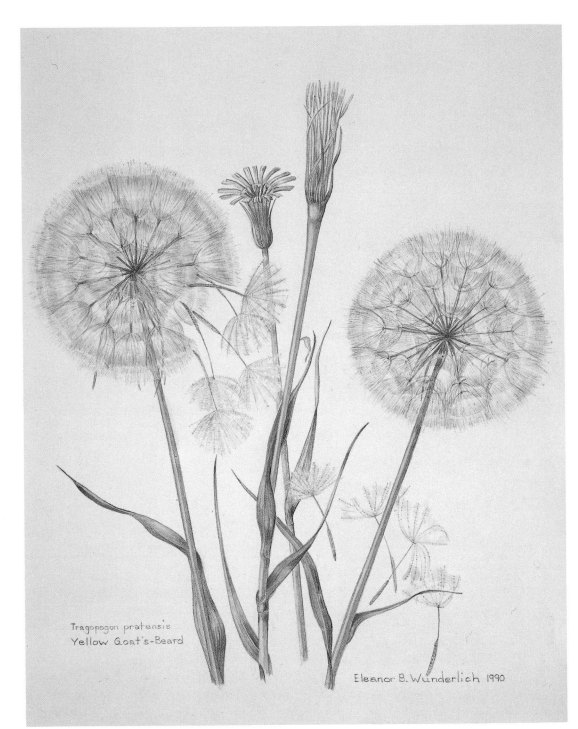

Tragopogon pratensis
Yellow Goat's-Beard

Eleanor B. Wunderlich 1990

Another example of a white flower against white paper is this picture of stock. A pale gray was applied first, leaving as many white areas of paper as possible. A second coat of gray was put on the more shaded areas until some of the shadows deep in the blossoms became almost black. Gray was also used to outline the petals. Wherever there was a spot of color, such as the greens and yellows at the center of each blossom, I used colors brighter than those in the actual plant to provide some contrast.

The leaves of stock are thick and curled. In painting them I used a light green for the initial layer and then added both blue-green and yellow-green to build up the color. "Fussing" built up their texture.

STOCK

(Matthiola incana)

WATERCOLOR ON
T. H. SAUNDERS WATERFORD
140 LB. HOT-PRESSED PAPER,
1990, 14 × 10" (36 × 25 CM).
COLLECTION OF THE ARTIST.

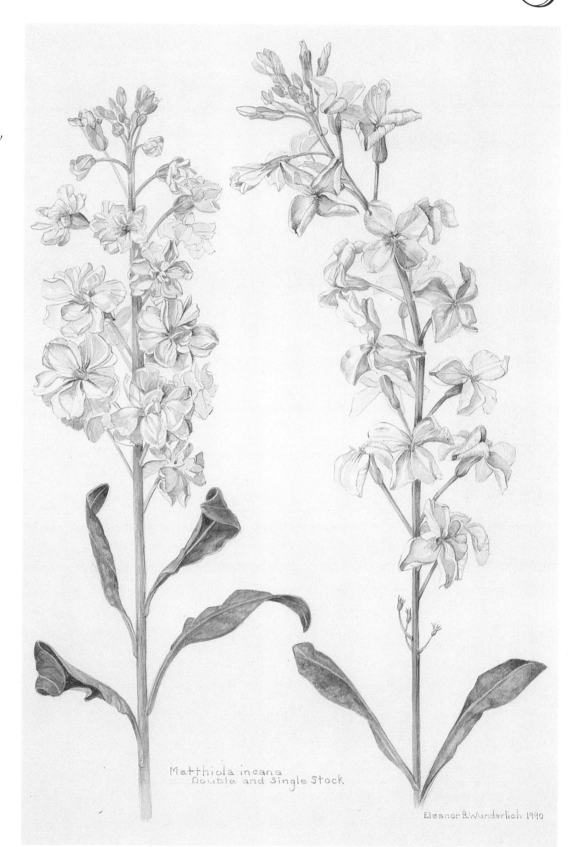

Matthiola incana
Double and Single Stock

Eleanor B. Wunderlich 1990

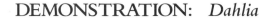

DEMONSTRATION: *Dahlia*

*D*ahlias were originally discovered in Mexico in the sixteenth century and named *Dahlia variabilis* because of their wide variety of flowers. This large double dahlia with its change in colors was too good to pass up, though the drawing alone took hours to accomplish. Once the flower was completed, leaves and buds were added not only for identification purposes but as design elements to round out the picture.

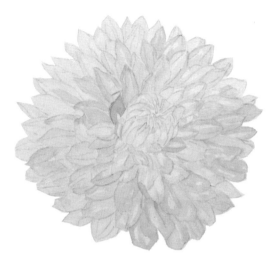

To paint this bicolored dahlia, I started with an application of Winsor & Newton crimson lake watered down to a very pale pink and used a wet brush. Winsor & Newton cadmium yellow pale, also watered down, was used for the yellow petals. The brush was a Daniel Smith kolinsky sable size 1.

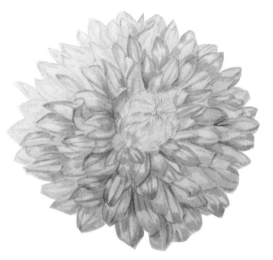

The petals were darkened at the base and tips with the same colors, only slightly intensified.

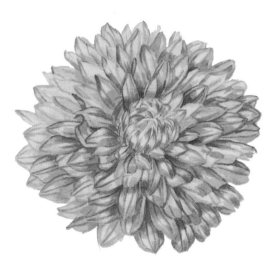

I continued darkening the petals, being careful to leave white areas on their tops where light hits them. This time I added a touch of green to the crimson lake to tone down the pink, and a bit of violet to soften the sharpness of the cadmium yellow.

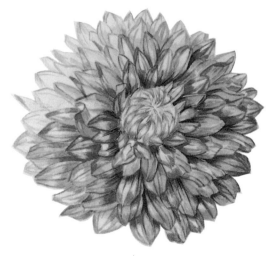

Some of the shading on the petals was done with fine lines made with the tip of a number 00 brush. On some of the outer petals, I carefully added pink to the yellow. Burnt umber was added to the pink for the deeper shadows at the petal bases, and to the yellow used on the tightly curled center petals.

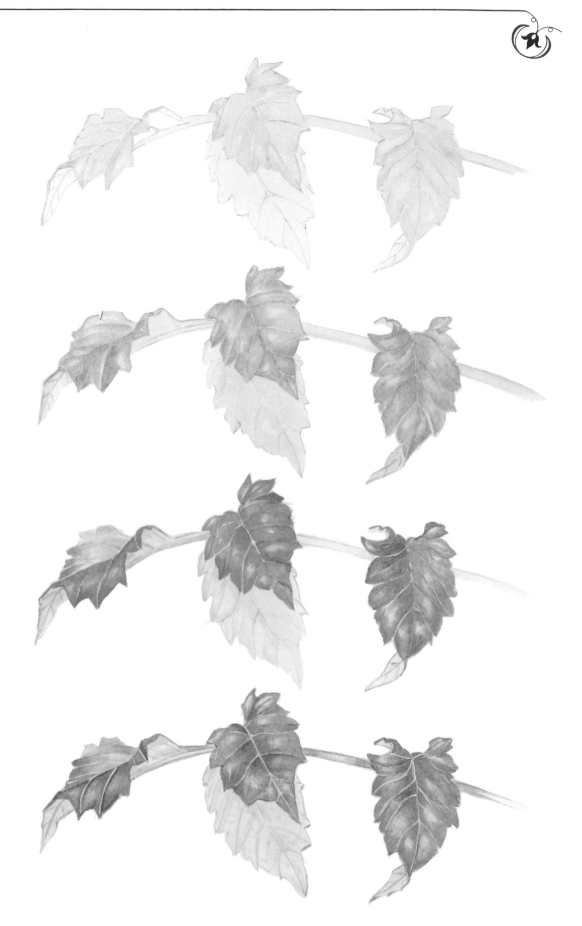

The initial coat of green for the dahlia leaves was thinned to a very pale color by the addition of water. I washed this onto the leaves and left light areas for the highlights. The stem also received a pale coat of paint.

More green was added to start the build-up of color on the top side of the leaves. A yellow-green was mixed and applied to the undersides.

Darker green emphasized the shadowed areas of the curved leaves. The veins on the top surface were left unpainted at this stage, though on the undersides they were indicated.

The veins were now painted in with white paint to which pale yellow was added. Highlights were refined by the careful addition of white paint blended into the green, and light brown was added to the stem to give it form and interest.

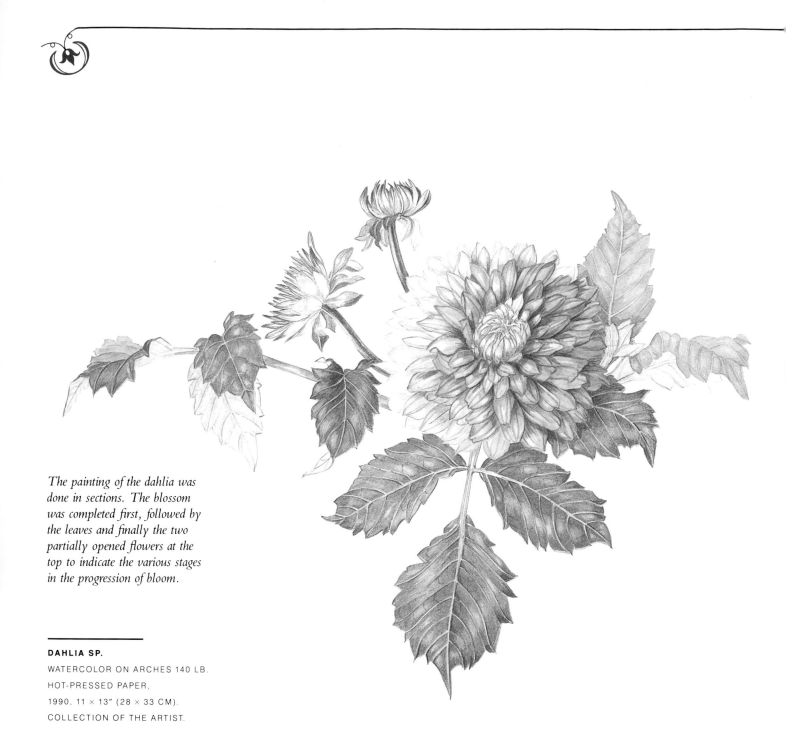

The painting of the dahlia was done in sections. The blossom was completed first, followed by the leaves and finally the two partially opened flowers at the top to indicate the various stages in the progression of bloom.

DAHLIA SP.
WATERCOLOR ON ARCHES 140 LB.
HOT-PRESSED PAPER,
1990, 11 × 13" (28 × 33 CM).
COLLECTION OF THE ARTIST.

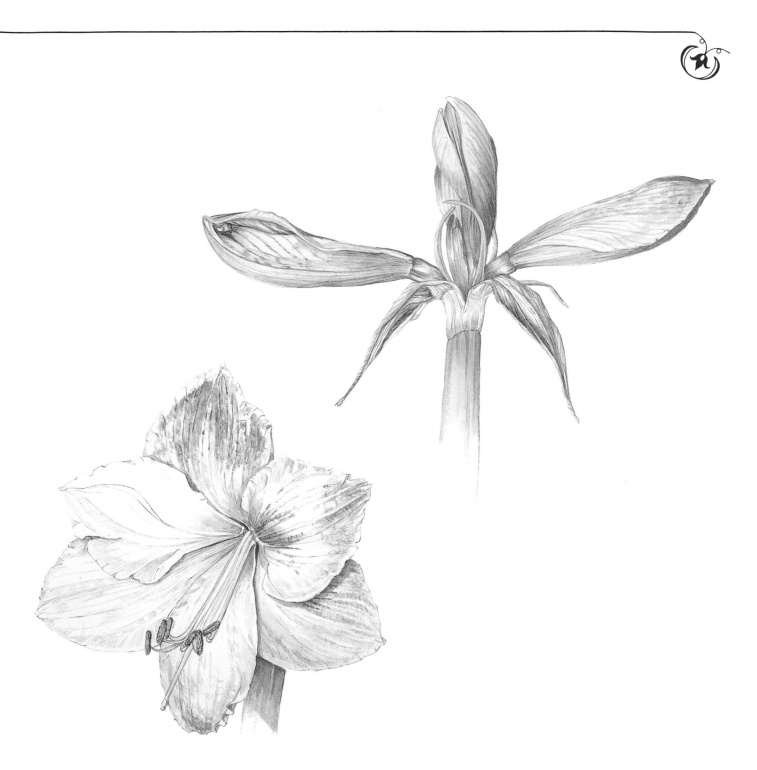

The budding stalk of the amaryllis was done first. Because a portrayal of this plant in full bloom would have been overpowering, only one blossom was depicted. The opened flower was partially finished in pencil on the left side of the picture, while the right-hand petals have been painted not only to show their color but to keep the overall design centered on the page.

The stamens with their brown anthers were carefully drawn and painted with the pistil extending beyond them. Florists will often strip the anthers from the stamens of lilies in order to prolong their blooming time, but to be botanically accurate, an illustration must show them. Anthers can vary in color from pale yellow to dark brown or near black, and they often form a distinctive pattern.

AMARYLLIS (HYBRID)

(Hippeastrum)

WATERCOLOR ON ARCHES 140 LB. HOT-PRESSED PAPER, 1990, 12 × 9″ (30 × 23 CM). COLLECTION OF THE ARTIST.

DEMONSTRATION: *Freesias*

These lovely, sweet-smelling flowers, members of the iris family, bring spring to mind though they are now available in many colors all year at florist shops. The tubular shapes, sprays of buds, and long, almost leafless stems make for interesting angular formations. Careful attention was given to the flowers, which were painted first. The interior depth of the flowers was indicated by the very dark shadows deep inside, which give a three-dimensional quality and draw the viewer in.

I began painting this freesia by applying a very pale gray, reserving the white of the paper for highlighted sections of the flowers. Pale green was applied to stem and buds.

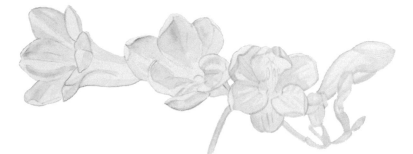

Next I added more of the pale gray to the already shaded sections to develop the form. The pistils and stamens were painted a very light pink, while touches of light yellow were added to the base of the petals. Additional green developed the form of the stems and buds.

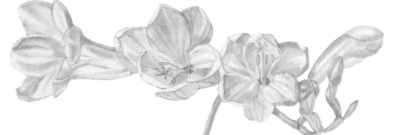

I continued developing the form of the flowers, being careful not to paint over the pistils and stamens.

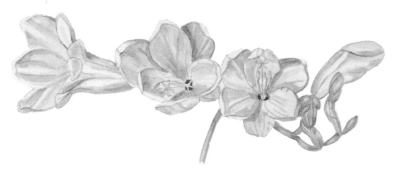

A much darker gray was used for the final touches to indicate the depth in the flower centers and to accent the edges of the petals. Some cadmium yellow medium brightened the stems and buds.

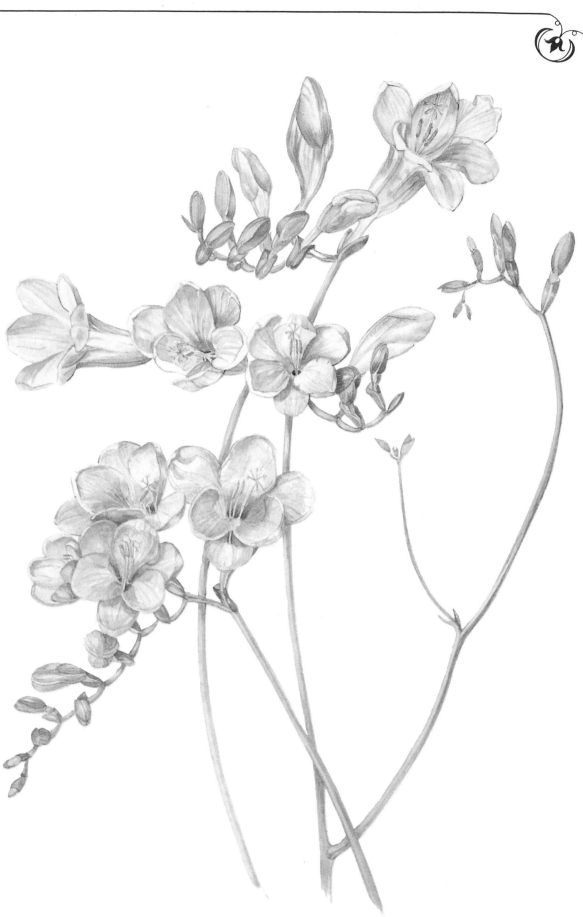

In the completed watercolor, three freesias form a graceful design. The yellow flower picks up the yellows on the petals of the white flowers.

FREESIA

(Hybrid)

WATERCOLOR ON
ARCHES 140 LB.
HOT-PRESSED PAPER,
1990, 14 × 11″ (36 × 28 CM).
COLLECTION OF THE ARTIST.

DEMONSTRATION: *Trumpet Vine*

The trumpet vine, which can be an invasive nuisance if left to its own devices, is an old-fashioned climber with flowers ranging from deep yellow through the oranges and reds. The vine is in continuous bloom all summer, and this habit is indicated by incorporating small unopened buds, those about to pop, and fully opened flowers in the same picture. The exteriors are considerably duller in color than the interiors, which show their brilliance as the petals open out and then curl back on themselves.

The leaves have a distinct form with a long, tapering end. They are pale green in color, making a delightful contrast to the rich hues of the flowers.

The shapes of the flowers of the trumpet vine were blocked out in a series of ovals in order to obtain the proper shape and perspective.

Once the shape was achieved, I did the drawing by fitting the flower heads within the ovals. Both this step and the preceding one were done on tracing paper. The drawing was then transferred to the watercolor paper.

The first pale washes of color were put on the flowers using a number 2 brush. Each petal was dampened, painted separately, and allowed to dry before the next was painted; this prevented the painted edges from running together. This particular variety of trumpet vine has flowers with a pink interior in contrast to the yellow-orange of the exterior. For the interiors, I used rose carthame mixed with cadmium orange. The exteriors of the flower tubes were painted with cadmium yellow medium toned down with a touch of violet.

More color was added to darken the flowers. The shaded areas help create their form.

Left: I deepened the pink of the interior, being careful not to paint over the stamens that protrude from the flowers. I also added some pale pink to the exteriors of the tubes. Burnt umber added to the exteriors deepened the shaded areas.

Right: Alizarin crimson was used next to darken the edges of the petals and interiors of the flowers. I carefully outlined the stamens in a brown-black and painted shading beneath the petals along the tubes with a browner yellow. A number 00 brush was used for this work.

TRUMPET VINE
(Campsis radicans)
WATERCOLOR ON
T. H. SAUNDERS WATERFORD
140 LB. HOT-PRESSED PAPER,
1990, 14 × 12″ (36 × 30 CM).
COLLECTION OF THE ARTIST.

The final painting shows stems and leaves were added and the finishing work of refining the details was completed. This is another illustration that shows several stages of the flowers.

This picture of a "Trick or Treat" orchid was built up from very pale original washes. The orange of the flower petals is darker at the ends to give form, and the addition of yellow varies the overall uniformity of color.

Like the petals, the leaves were developed from an initial coat of pale green put on a wet surface. Light areas were left to convey the sheen on the leaf surfaces. Orchids have thick, awkward foliage, which can lead to difficulties in design. Making them appear graceful is a challenge to the artist.

The gray of the sheathlike coverings on the lower sections of stem was put on those areas first, followed by light green applied carefully between the ribbing to indicate the green stem underneath. The root system was worked out carefully on tracing paper before being drawn and painted on the final picture.

"TRICK OR TREAT" ORCHID

(Laelia cattleya)

WATERCOLOR ON ARCHES 140 LB.

HOT-PRESSED PAPER.

1988. 14 × 11" (36 × 28 CM).

COLLECTION OF THE ARTIST.

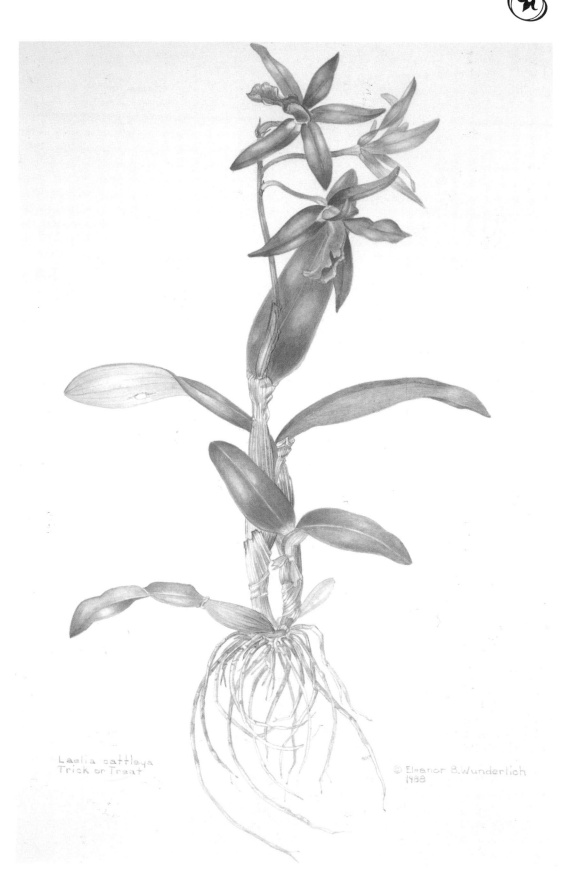

Laelia cattleya
Trick or Treat

© Eleanor B. Wunderlich
1988

DEMONSTRATION: *Bicolor Rose*

*B*ecause roses are probably the most popular of flowers, hundreds of varieties are available. Most hybrids have dark, shiny leaves that make a good exercise for an artist even without the flowers.

When drawing the rose, start with the tightly curled center petals, since all the rest surround them. A straight vertical line drawn through the middle of the blossom to indicate its center helps immensely.

These leaves were from a florist's hybrid rose. First I carefully drew them, as demonstrated on page 59. To begin painting them, I applied a light, wet wash of green in the first step. The stem and thorns were indicated with Indian red.

The second step was the addition of the same green to the sections of the leaves closest to the midrib and on the outer edges. A pale shadow was run down the right side of the rose stem.

I continued adding green to the leaves and darkened the midribs and veins of each leaf. I also deepened the shadows on the stems.

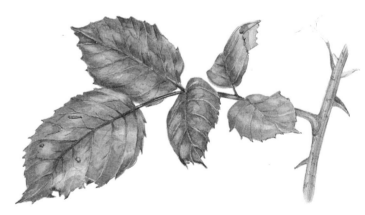

A much darker blue-green was now added to the leaves. The midribs and veins have been brightened by the addition of Winsor red toned down slightly by the addition of a touch of green paint. In some areas a wash of light blue was applied to give the necessary variation to the colors of the leaves. Shadows on the main stem were intensified, and the thorns were clearly defined.

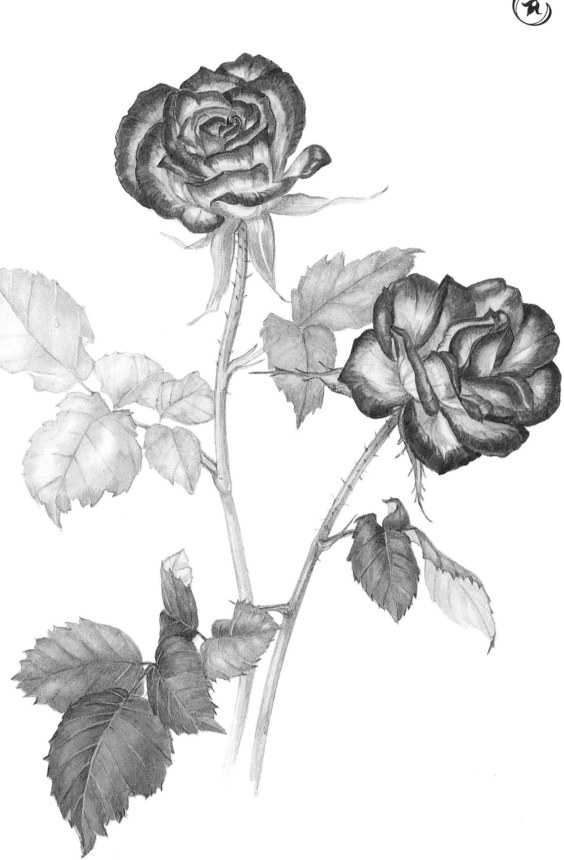

The lower sections of the petals on this bicolor rose were painted first with a light yellow. The pinks and reds were then added to the outer edges. Shading was done last: The yellow areas were deepened at the bases of the petals, and shadows were placed beneath the petals where they overlap.

BICOLOR ROSE (HYBRID)

(*Rosa sp.*)

WATERCOLOR ON ARCHES 140 LB.
HOT-PRESSED PAPER,
1990, 12 × 8″ (30 × 20 CM).
COLLECTION OF THE ARTIST.

This large slipper orchid grew from a plant with several groups of leaves whose overlapping growth pattern made an interesting design. The thickness of the leaves is shown by the delineation of the leaf edges in light yellow gouache. (For more about this, see page 58.) This view of the flower shows its structure from the back, a view not often shown in flower paintings.

SLIPPER ORCHID (HYBRID)

(Paphilopedilum sp.)

WATERCOLOR ON ARCHES 140 LB.
HOT-PRESSED PAPER,
1990, 14 × 11″ (36 × 28 CM).
COLLECTION OF THE ARTIST.

Paphilopedilum
Florist hybrid

Eleanor B. Wunderlich 1990

CYCLAMEN

(Hybrid)

WATERCOLOR ON ARCHES 140 LB.
HOT-PRESSED PAPER,
1990, 12 × 11″ (30 × 28 CM).
COLLECTION OF THE ARTIST.

Several blossoms of the cyclamen, ranging from tiny unopened buds to partially and fully opened flowers, are shown in this painting. Each blossom and leaf has its own stem leading from the base of the plant. Many stems were partially covered by the leaves, an effective way to break up the long, thin, distracting lines that would result if the stems were all in view. The stems have been darkened near the flower heads and under the leaves but left lighter in between in order to minimize them. This enhances the picture's overall design.

A native of sphagnum bogs, the pitcher plant is unmistakable. The leaf blades are modified to form deep, hollow, insect-catching pitchers, while the flower has a large, flattened, umbrellalike pistil.

The green areas were painted first, including the shadowed sections. I then added the dark purple-red, both into areas left light and directly over the green. The delicate veins were done last. The long stems were made a feature in the design of the picture. The line drawing of the frog gave an indication of the plant's habitat.

PITCHER PLANT

(Sarracenia purpurea)

WATERCOLOR ON ARCHES 140 LB.
HOT-PRESSED PAPER,
1988, 14 × 11″ (36 × 28 CM).
PRIVATE COLLECTION.

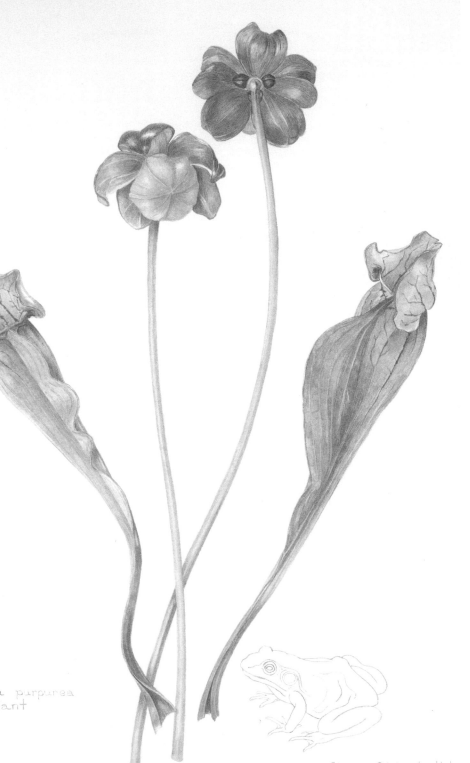

Sarracenia purpurea
Pitcher Plant

© Eleanor B. Wunderlich

PAINTING

\mathcal{F}ERNS AND \mathcal{V}INES

Ferns present specific problems in perspective because the leaflets (pinnae) overlap, but the artist is given the opportunity to juxtapose light and dark when showing the fronts and backs of each leaf. Many have patterns of colorful dots on the undersides of the fronds. These are the sori and contain the spores of the fern. When painting ferns, the artist should not overlook the sori, since they form not only an identifying part but a highly decorative design.

Vines are a source of delight because their trailing tendrils can be arranged to suit the artist's fancy. Since vines both flower and fruit, it is perfectly acceptable to show both phases on the same vine, though it should be noted in the margin the difference between flowering and fruiting times.

DEMONSTRATION: *Maidenhair Fern*

The maidenhair fern is considered by many to be our most beautiful fern, with species growing wild in both the northern and southern sections of the country. The enlarged pinnule below shows how the paintings on pages 116–117 were done.

Here is an enlarged pinnule with the initial pale green wash.

Additional color has been added to the first coat.

The addition of fine rib lines shows the direction of each part of the pinnule.

Shaded areas have been added to the lower edges by sweeping the brush over the already painted surface.

Brown has been touched in to show spots of leaf burn, and a wash of pale yellow has been applied over the entire surface.

After completing a careful drawing, I applied the first coat of pale green to the pinnules (leaflets) as shown on the left side of the picture **(a)**. The wiry black stem was done with a number 00 brush.

A second layer of paint was applied to the pinnules as shown on the two center blade divisions **(b)**. Here the pinnules begin to show curvature and form.

The same procedure was followed on the two blade divisions on the right **(c)**. Then the ribs of the pinnules were added with a number 00 brush. I studied the direction of the tiny ribs on each pinnule carefully because they show the growth pattern and are a distinctive feature of this fern.

The lowest blade division **(d)** shows a completed section with touches of brown and a wash of pale yellow over each pinnule to heighten the color.

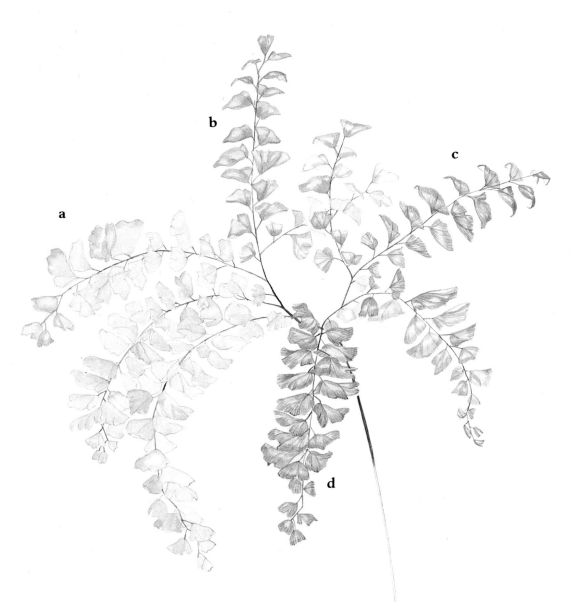

The completed watercolor includes additional ferns in varying degrees of development. The completed stems lead into the root system.

This particular fern was bought at a nursery, kept in its pot in the studio until the painting was completed, and then planted outdoors. It continues to thrive.

MAIDENHAIR FERN

(*Adiantum pedatum*)

WATERCOLOR ON ARCHES 140 LB.
HOT-PRESSED PAPER,
1986, 13½ × 11½″ (34 × 29 CM).
COLLECTION OF THE ARTIST.

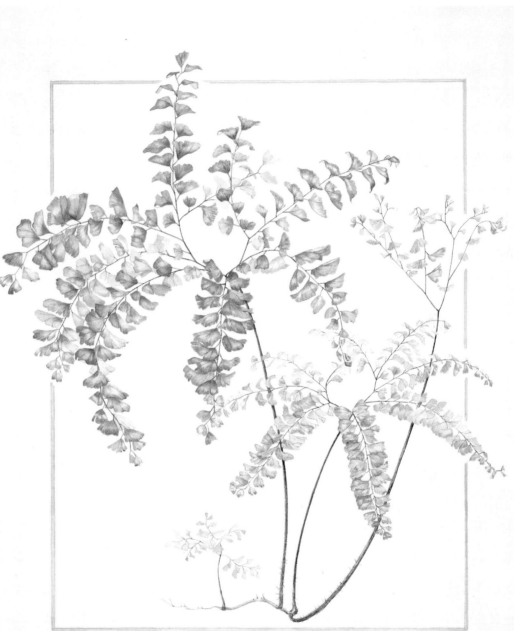

Adiantum pedatum
Maidenhair Fern © Eleanor B. Wunderlich 1986

DEMONSTRATION: *Creeping Myrtle*

One of the most satisfactory vines to draw and paint is the creeping myrtle, whose tendrils form graceful arcs that are visually pleasing, with the flowers interspersed. The overall scheme for this painting had to be worked out on tracing paper. Several pieces were used and overlaid to make an arrangement of the various parts and details that finally produced an artistic work. The partially finished version below illustrates several stages of the picture's development simultaneously.

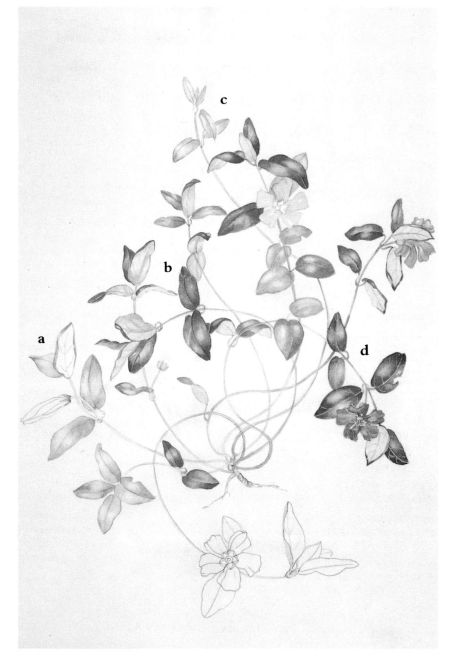

(a) The leaves on the left illustrate the first application of color. Each leaf was given a dampening with clear water. I then applied the green with a number 1 brush to each end and smoothed it with a clean wet brush toward the center. This technique leaves very light areas where the color has thinned out to almost white to represent the glossy surface of the leaves. The green used was a combination of Hooker's green dark, oxide of chromium, and a touch of red to tone down the color.

(b) At center left another layer of the same green was applied to the tops of the leaves in the same manner as the first coat of paint. The undersides of the leaves were given a pale wash of color consisting of the same green to which lemon yellow was added. This yellow-green was also used for the first layer of paint on the stems.

(c) The small group of leaves at the top of the picture was painted in yellow-green because it represents new and tender growth. The leaves on the older parts of the vine become darker and more blue.

(d) Leaves on the right side were deepened with the original green to which Winsor permanent blue was added with a touch of red. A light coat of permanent magenta was washed onto the blossoms. The stems had more color added to darken them, particularly near the leaves and flowers, but I left them pale between.

Next I added more magenta to the flowers, followed by a light wash of crimson lake that was watered down to a light pink. Touches of brown were added to the leaf at the right, surrounding an area chewed by insects. Veins were carefully painted with a sharp-pointed brush using Pro White with a touch of lemon yellow.

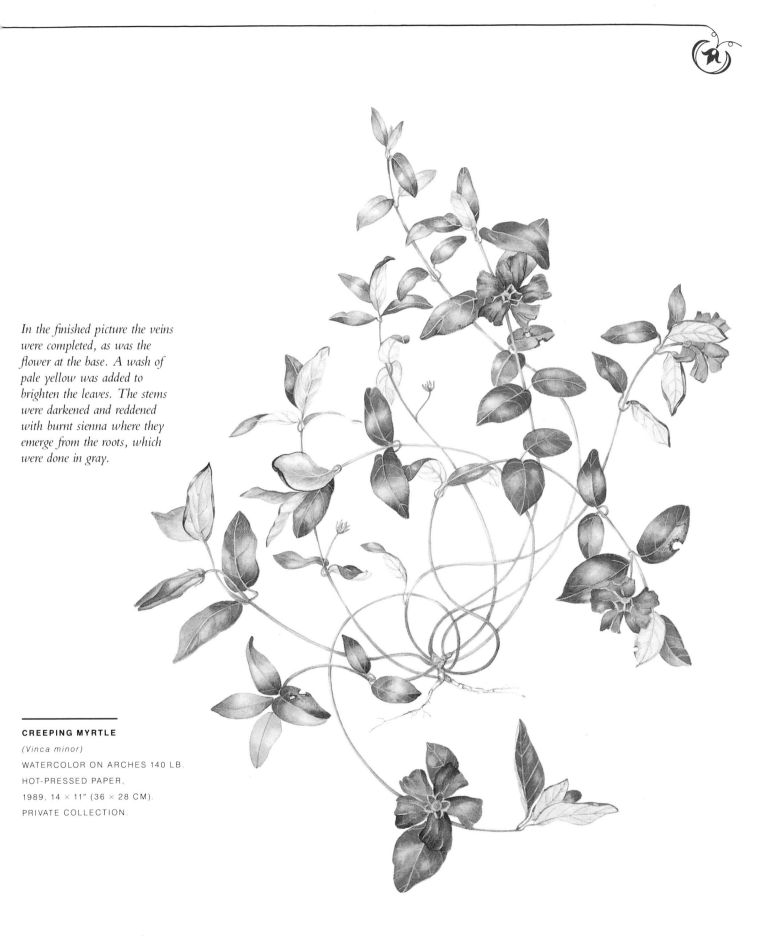

In the finished picture the veins were completed, as was the flower at the base. A wash of pale yellow was added to brighten the leaves. The stems were darkened and reddened with burnt sienna where they emerge from the roots, which were done in gray.

CREEPING MYRTLE

(Vinca minor)

WATERCOLOR ON ARCHES 140 LB.
HOT-PRESSED PAPER,
1989, 14 × 11″ (36 × 28 CM).
PRIVATE COLLECTION.

P A I N T I N G

Mushrooms and Other Fungi

Unless grown indoors as a hobby or bought at a vegetable counter, mushrooms are usually not available in the winter months. During their growing season they can often be found in abundance in meadows and forests. It is best to extract them carefully from their growing medium so as not to damage the stems, bases, and whatever root system may exist. This can be done with the aid of a pocket knife.

With their wide variety of colors and shapes, mushrooms are fascinating to study and paint. Very careful attention must be paid to all portions of the growth, since identification can hinge on cap and gill color, gill attachment, length of stem (stipe), and size, which should be indicated. Shelf fungi growing from trees can be found even in winter. Their colors range from the palest browns to rich blue-blacks.

DEMONSTRATION: *Mushroom*

The *Clitocybe gigantea* pictured here was one of a dozen or more growing from an old downed tree trunk in the forest. All were at least twelve inches across, making a most spectacular formation.

The surface of the drawing of this large mushroom was dampened with clean water using a number 3 brush. When dampened with enough water, the paper should stay wet for approximately two or three minutes, during which time the paint can be layered on, moved around, added to, or removed. Onto the wet paper I washed a light brown made from burnt umber and cadmium yellow pale, starting at the outside edges and brushing it toward the center. Because the depressed center of the mushroom was almost white, I carefully lifted out with a clean brush any of the brown that spread into the area.

While this first wash was still damp, I touched a light gray made with burnt umber and Winsor blue into the shaded areas on the top of the mushroom. Next I did the mushroom stem in the same fashion, being careful to leave white the areas where the mushroom had been chewed by insects.

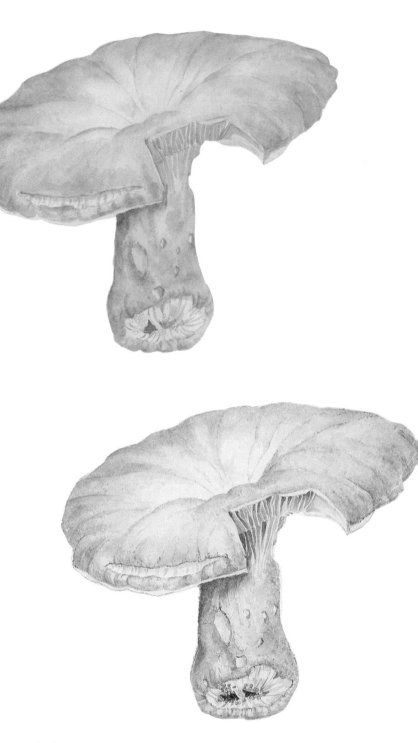

Here the color has been deepened, particularly on the outer edges of the mushroom cap and in the shaded area under the cap on the stem. Some gray shading has also been applied to begin defining the breaks on the mushroom surface and stem.

GIANT CLITOCYBE

(Clitocybe gigantea)

WATERCOLOR ON ARCHES 140 LB.

HOT-PRESSED PAPER,

1988, 14 × 11″ (36 × 28 CM).

COLLECTION OF THE ARTIST.

In the finished painting, the outer edges have been deepened by adding still more color. Because this mushroom has a flocked, or somewhat velvety, surface, finishing work consisted of touching the brush with a dabbing motion very lightly to the already painted areas to produce the desired effect. This type of work takes considerable time and patience, so it should not be done in one sitting. The bottom of the stem was completed with very dark gray, as were the shadowed edges of the breaks on the mushroom skin. The shadows between the gills were also intensified.

P A I N T I N G
Bulbs and Roots

Many artists are so intent on painting flowers that they tend to overlook the bulbs and roots from which they grow. Spectacular blossoms such as amaryllis and agapanthus (Blue Lily of the Nile) spring from huge bulbs that are things of beauty in themselves. More common and readily available are the members of the onion family. Because all plants have roots of one kind or another, they are an important subject for the botanical illustrator to understand and delineate correctly. And many a stunning design can be created by a carefully drawn and painted root system.

DEMONSTRATION: *Paperwhite Narcissus*

The bulb of the paperwhite narcissus has, upon close inspection, blues, reds, and yellows in what at first glance appears to be merely brown. The many thin, translucent layers of skin were developed from the very palest of pigments, with darker and more varied colors added as the work progressed. This particular bulb had a "busy" appearance and had to be simplified to keep it from overwhelming the remainder of the picture.

I used a number 1 brush to apply the initial lightly painted areas, using a mixture of cadmium yellow light and burnt umber, and leaving white areas to indicate the shine and delicacy of the different layers of skin. Next a light brown consisting of burnt umber and burnt sienna was painted on some of the outer skin in order to show the wrinkled surface and to add color to the leaf stalks. A very pale green consisting of oxide of chromium mixed with lemon yellow was applied to the freshly starting leaves. All colors were watered down to very pale tints to be darkened with additional layers of color as the picture progressed.

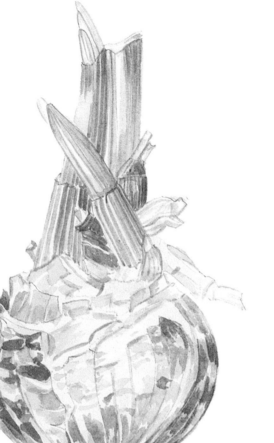

More brown was added to the bulb. I also added yellow but still left white paper for highlights. Darker green was added to the leaves, while red mixed with brown was put on the outer layer of skin on the left side.

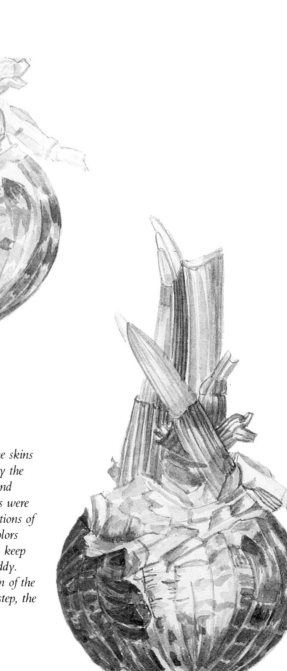

The different layers of the skins were further developed by the addition of dark brown and bluish gray. Slender lines were painted on the brown sections of the leaf stalks. All the colors were carefully applied to keep them from becoming muddy.

 Because the addition of the roots would be the final step, the base of the bulb was left untouched.

To start the painting of the florets that make up the flower head, I put a pale gray outline around the petals and center "cups." Normally, outlining petals is unnecessary, but this is one way to show the florets against a white background. I also applied pale green to the stems. Note each floret has its own stem; it is important to be accurate with such details.

Light gray shading was washed onto the petals. I painted the florets toward the back almost completely, while reserving considerable white areas on those toward the front. The shadows indicate that the source of light is on the left.

A light brown was put on the filmy outer casing at the base of the flower. I added darker green to the stems to give them more form and emphasis, and put a very light green in the center of the "cups," while being careful not to paint the stamens.

In this stage I further darkened the shadows to build up the form of each floret and give shape to the overall flower. The stamens were painted a deep yellow, and more brown was added to accentuate the filmy casing. Most of the painting on the flower was done with a number 1 brush, but number 0 and 00 brushes were used for the finer details.

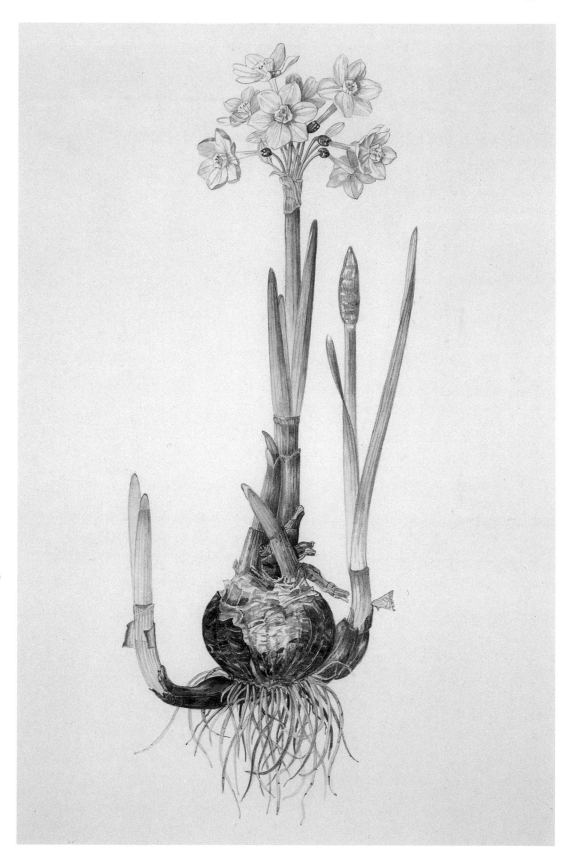

The final picture shows the addition of the root system. In order to draw and paint the roots, I lifted the entire bulb from its growing medium, cleaned off the roots, and separated them from one another. Each root was carefully rendered so that they would not look like strings attached to the bottom of the bulb. Two bulblets sprouting new growth were a further addition.

PAPERWHITE NARCISSUS
(Narcissus tazetta, var. grandiflora)
WATERCOLOR ON ARCHES 140 LB.
HOT-PRESSED PAPER,
1989, 15 × 11″ (38 × 28 CM).
COLLECTION OF THE ARTIST.

DEMONSTRATION: *Garlic*

*M*ost bulbs have a mix of colors. The thin layers of skin overlapping one another catch and reflect the light, so that bright highlights are juxtaposed with dark shadows. The garlic shown here, a white or off-white object, has a sheen to its surface rather like a dull, satin finish.

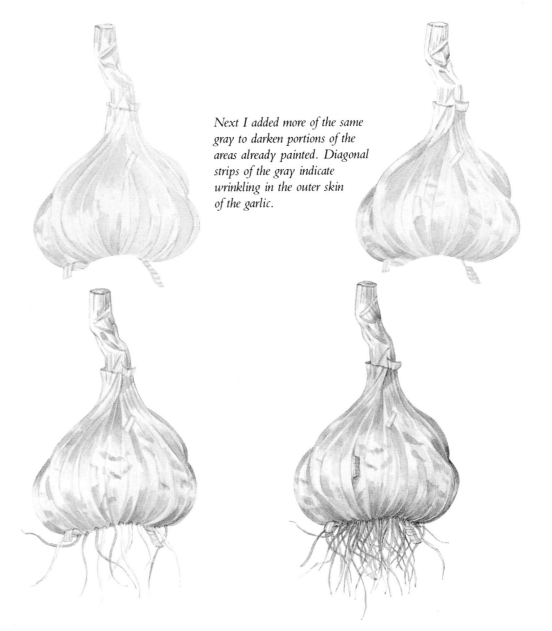

Here I applied a light gray, reserving the white for highlighted sections. (For the preliminary drawing, see page 61.)

Next I added more of the same gray to darken portions of the areas already painted. Diagonal strips of the gray indicate wrinkling in the outer skin of the garlic.

The process of adding more gray continued, and I began to draw the roots in pencil. Light brown, a mixture of burnt umber and burnt sienna, was painted on a few of them, as well as touched to the clipped top of the garlic.

This final stage shows the dark gray accents that were added to sharpen the edges and deepen the shadows. Slight touches of the light brown add interest to an otherwise gray object. The root system was further developed by careful pencil drawing in which each root can be traced all the way from its tip to where it joins the bulb, passing behind and in front of other roots along the way. Light and dark gray roots were interspersed with the brown ones.

DEMONSTRATION: *Yellow Onion*

*L*arge yellow onions have a subtle mix of textures on their surfaces. The twisted ends at the top have a dry look with a flat color, while the various layers of skins flash brightly where the light strikes. The initial coat of paint on the main body of this onion was applied to a wet surface. I left fairly large areas untouched by the brush so that the white paper would create the highlights. The darker colors added around the unpainted sections gave the desired contrast that makes up the shine.

After transferring my initial drawing (which you can see on page 61) to watercolor paper, I put the first very light washes of color on the onion, reserving wide areas of the white paper for the highlighted sections. The colors used were burnt umber mixed with burnt sienna and a small bit of cadmium yellow light.

Slowly more of the same color was painted over the initial washes, still reserving the white areas. More yellow was added for the body of the onion beneath the outer layer of skin. The papery extension of the skin at the top was intensified by the addition of light gray lines "drawn" on with a number 00 brush.

At this stage I intensified the reddish brown of the outer skin and added some soft yellow to the body to give it a rounded form. The onion's surface had some creases, which were added with a darker brown.

Shadows done with a fairly dark gray were added to delineate the edge of the skin and to round out the form of the extension at the top of the onion. A pale pink was washed carefully over the exterior skin to give more body to the existing color. Highlighted areas remain pure white on the top left-hand side. A low light, slightly less white than the highlight, remains on the right side of the vegetable because of reflected light. For the finished painting, to which I added a leek for a strong linear contrast, refer to page 17.

P A I N T I N G
Trees and Shrubs

Botanical illustration can and does include the largest of growing plants. However, for most purposes only a portion of trees or shrubs need be depicted. A leaf attached to a twig—or a small branch with leaves, flowers, or fruit—can suffice to identify a much larger plant. (As mentioned earlier, the artist has the option of doing a small drawing in a corner of the picture to show the overall structure of a tree.) Many field guides show the full-grown tree in silhouette, a perfectly acceptable method.

Leaves in late fall and winter take on unusual color and form and make excellent painting subjects. Since the object as always is accuracy for identification purposes, it is important to pay attention to leaf veins, bark patterns, and bud and leaf scars.

Betula lutea
Yellow birch

Eleanor B. Wunderlich 1989

YELLOW BIRCH

(Betula lutea)

WATERCOLOR ON
T. H. SAUNDERS WATERFORD
140 LB. HOT-PRESSED PAPER,
1989, 6¼ × 9½" (16 × 24 CM).
COLLECTION OF THE ARTIST.

This short piece of a yellow birch branch, about four inches in diameter and twelve inches long, was found on the ground where it had lain for several weeks. While painting it, I stood back from the picture often to see how its cylindrical form was taking shape. Because its interior was decomposing, the exterior bark had a softer consistency than that of a branch freshly cut from a tree. I painted the light grays first, darkening them to indicate shaded sections and the various undulations on the surface. The soft golden yellows were then added. The very dark areas, both where the bark was split and at the open ends, were built up from gray to black.

Cornus kousa
Japanese Dogwood

© Eleanor B.Wunderlich 1987

The beautiful flowers of the Japanese dogwood were done against the background of dark leaves, which helped to show them off. I removed some foliage from this branch in order to create a clear, uncluttered picture. Dogwoods can be recognized by the horizontal growth of the branches and by their leaves, which have long, tapering ends and veins parallel to the outside edges.

The fruit of the Japanese dogwood appears and ripens over a period of two to three months following the flowering. These consist of deep rose berries, with a net-veined surface, that hang by long stems from the branch. They are completely different from the clusters of hard, bright red berries on the native American flowering dogwood (Cornus florida).

Observation of the overall growth and shapes of various parts is important when rendering branches of trees and shrubs. Since only small portions are depicted in botanical illustration, the plant has to be recognized from the accuracy of the details in the picture.

JAPANESE DOGWOOD

(Cornus kousa)
WATERCOLOR ON ARCHES 140 LB.
HOT-PRESSED PAPER,
1987, 11 × 14″ (28 × 36 CM).
PRIVATE COLLECTION.

DEMONSTRATION: *Black Oak Leaf*

The black oak reaches a height of one hundred feet or more. This twig with the large leaf attached was from a young immature tree still low enough to be reached; it was cut in November. Many colors could be seen and were applied after the initial wet washes of pale brown. Different effects were achieved by using a very small brush to stipple and cross-hatch, since the leaf showed its age with many different markings.

The twig from which this black oak leaf grew was an important part of the picture. I began painting it with a base coat of pale gray. As the work progressed, tans and darker gray were added. The final steps included additions of near black with tiny spots of white to indicate the various surface textures of the wood. The leaf buds grow at the axils of leaf stem and twig. These were painted a light brown made from burnt sienna and burnt umber thinned with water. The spiraling lines were added with a number 0 brush after the paint was dry.

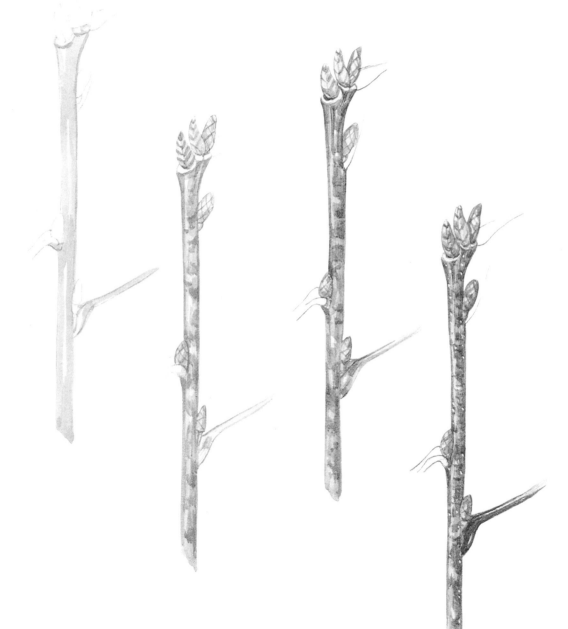

Unlike the eggplant on page 89, which has an all-over shiny, smooth skin and had to be painted as a whole with a completely wet surface, this black oak leaf was segmented by strong veins and had many different textures caused by age cracks, insect holes, dried and fragile areas. Therefore, I applied a wash of clear water to one section at a time, using the veins of the leaf as boundaries, so as not to be working large areas. While the paper was wet, I applied a light yellow-green followed by the light brown. The colors were smoothed into each other but were not applied over each other. Very pale areas of wash were left, as well as sections of completely white paper.

The upper half of the leaf shows the second step: adding more brown to bring out the contours of the leaf. The lower half shows the continuing process of adding more color. More green was applied followed by darker brown and touches of Indian red. I dabbed on the paint with the brush to give a dappled effect and took care to leave the small holes caused by insects unpainted.

The finished leaf required many more layers of paint, most of them applied by the same dabbing technique to show the somewhat dried texture. The veins were painted with a near black highlighted with white.

BLACK OAK

(Quercus velutina)

WATERCOLOR ON ARCHES 140 LB.
HOT-PRESSED PAPER,
1989, 12 × 9″ (30 × 23 CM).
COLLECTION OF THE ARTIST.

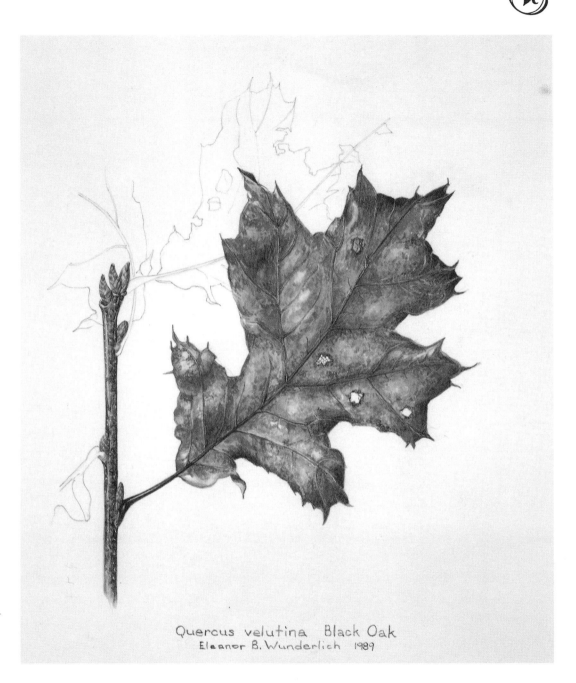

Quercus velutina Black Oak
Eleanor B. Wunderlich 1989

Finishing Up

PAINTED TRILLIUM

ENHANCING YOUR WORK

When you have finished choosing a good botanical subject, planning the design of your picture, drawing it, and painting it in watercolor, you have reason to congratulate yourself on a job well done. But your painting is not quite done until it is protected from damage and attractively displayed for potential viewers.

LABELING

Plants should be accurately identified with the Latin name followed by the common name. When writing the Latin name, capitalize the genus and lowercase the species (for example, *Campsis radicans*). If you do not know the precise species—and in some genera the identification is very complex—it is acceptable to state only the genus followed by "sp." for species. (For example, *Rosa sp.* means an unidentified species of rose.) Print this information at the bottom or to one side of the pictured material. Then sign and date your work. Also include the location where the plant was found, particularly if you obtained it at some unusual or exotic site.

MATTING

Watercolors should be matted. A mat will enhance the picture and protect it from contact with the glass after the picture has been framed. (Moisture can form behind the glass with weather changes and will transfer to the picture, causing permanent damage, unless the picture is separated slightly from the glass.)

The color of the mat itself can bring out the colors in the picture; the effect can be further heightened by applying narrow strips of tinted, gold, or marbleized papers to the mat, at least ⅛ inch from its inner edge. However, no mat should be so colorful as to detract from the picture itself.

Mats can be made by the artist. Mat board in many colors and mat-cutting devices are available at art supply stores. Many art galleries and stores, some specializing in this field, will cut individual mats for artists' work. Not to be overlooked are the ready-made mats available in many colors and sizes, which are relatively inexpensive and convenient.

Mats should consist of two pieces of mat board. The front piece, in whatever color and style are selected, is cut to frame the picture. The picture is then fastened or "hinged" to the back piece, and the front and back pieces of the mat are joined along one side.

Self-adhesive, or pressure-sensitive, linen cloth tapes are durable, non-wrinkling, and suitable for joining the two pieces of mat board. For hinging the picture to the mat board, use an acid-free "water-activated" or "water-reversible" linen tape, which can be sponged off with water if you later decide to reframe the picture. Make "hinges" by folding the tape so that one gummed half is on the mat board and the other on the back of the top of the picture. In this way the front of the picture is kept completely clean. If the picture is not to be immediately framed, place a piece of tracing paper over it for protection from dust and moisture, or wrap it in heat-sealed plastic covering.

FRAMING

\mathcal{F}rames for botanical illustrations are best kept simple. A narrow gold or natural wood frame seems to complement the delicacy of the artwork that a more ornate frame would overwhelm and obscure.

Wood moldings can be bought by the foot if the artist elects to make his or her own frames. Again as with mats, commercial art galleries and art supply stores offer frame-making as a service. Metal framing systems consist of framing material that comes in strips and can easily be made to fit any picture. These are less expensive than wood and are a major convenience to the exhibiting artist, since the pictures can be changed with ease. Clear plastic box frames that hang flush with the wall and various clip systems that hold mat and glass together are also suitable for exhibition pur-

poses, though not as durable as permanent frames of wood or metal.

Good frames can sometimes be found at flea markets and tag sales. These can be obtained inexpensively but often need to be sized to the picture and refinished.

Framing includes glass for the front of the picture. Clear plastic can be used in place of glass, particularly if pictures are to be shipped to exhibitions, but over a period of time the plastic will scratch. The non-reflecting glass unfortunately makes pictures look dull and lifeless.

The back of the picture in its mat should be covered by an acid-free cardboard held in place to the frame by thin wire brads. The whole should then be covered with brown paper taped to the back of the frame to keep out air and dust.

This "exploded" diagram shows the layers of the matted and framed illustration: (a) frame with glass, (b) front mat piece, (c) picture fastened to back mat piece, (d) back mat, and (e) backing to fit to frame, held in place with wire brads.

After the framed picture has been assembled, a piece of sturdy brown paper is used to cover the entire back to keep out dust, moisture, and air. Screw eyes and wire are attached to the back of the frame approximately one-third of the way down from the top on each side for hanging.

PRESENTING

*P*resenting pictures in their best possible light requires significant time and effort. A picture soiled by finger marks, drops of paint, or anything else—and surrounded by an ill-fitting mat and an unsuitable frame—will be disqualified by a jury immediately. Pictures hung in unjuried shows in such a condition will be criticized by the viewing public and ignored by judges awarding prizes. A professional dealer will certainly note the overall condition of the pictures and take it into consideration when looking at an artist's work. Taking the time to prepare and present your artwork properly may be costly and seem onerous, but it is essential to recognition and success.

EXHIBITING

*A*rtists wishing to become known in their field should have their work exhibited publicly. Many local businesses and organizations look for pictures to be shown either on their walls or in exhibition cases as a means of good public relations and promotion for the community. Check the possibilities of showing at places of business, banks, libraries, churches, and synagogues and see if they are interested in exhibitions. (Make sure your work will be adequately protected in these locations.) Enter local art shows sponsored by civic groups. Groups of artists can band together to put on their own shows, with the public invited.

Juried shows are exhibitions to which artists submit their work for acceptance. Usually a panel of three qualified jurors decides on the pictures to be hung in the show, and acceptance is an honor. Keep a list of shows you have entered and any awards you have won; such a list can add up to an impressive résumé over a period of time. It should be noted that although botanical illustration is a popular art form it is still, in the eyes of many jurors, illustration rather than fine art and may be disqualified for this reason.

BUSINESS ASPECTS

*A*ll serious artists should make themselves aware of current business practices that pertain to the art field. Many lawyers now specialize in such matters as copyright laws, royalties, commissions, contracts, and reproduction rights, to name a few. Artists' magazines occasionally list legal firms interested in art and artists. Many books on commercial art include chapters giving business guidance, and art schools provide courses on the business side of painting. As an artist, you may not have a full grasp of all the technicalities of the law as it involves you and your work, but you should know whom to turn to if you ever need advice and help.

If you intend to be a professional artist, find an art dealer who will handle your work on a business basis. Prices should be established, and you must be aware of the gallery commission and any other expenses that are involved. Since not all art dealers are interested in botanical illustration or can sell it, the right dealer should be found. This may entail sending slides of your work to dealers outside of your own community, or taking a portfolio of work around to galleries for inspection.

\mathcal{B}IBLIOGRAPHY

Although the botanical illustrator must learn primarily by observing nature, many written resources can be of tremendous assistance. I have divided this list of bibliographic resources into two sections: those dealing primarily with botany and botanical illustration, and those offering assistance with the more technical aspects of the botanical illustrator's craft.

BOTANICAL RESOURCES

Any collector of books and other written materials pertaining to botanical illustration has discovered the necessity of purchasing them when first seen or first published. Most art books of this type do not go into second printings or further editions, so they become scarce in the marketplace in short order. Dealers in gardening books sometimes carry little-known works, while specialists in rarities and book-hunting companies are good at locating out-of-print items. Browsing through library sales, flea markets, and second-hand bookstores can turn up some unexpected treasures. Not to be overlooked are the beautifully illustrated catalogs published by museums, art dealers, and auction houses written for the promotion of specific exhibitions and sales.

Some of the earliest botanical illustrations in watercolor and gouache were done as borders to the illuminations in medieval and Renaissance prayer books and books of hours. George Braziller, Inc., has published beautiful reproductions of these early books. The Pierpont Morgan Library in New York City has published illustrated catalogs in conjunction with exhibitions of early manuscripts and for specific shows of botanical works of art.

The Hunt Institute of Botanical Documentation, Carnegie-Mellon University, Pittsburgh, PA 15213, is a vast resource of historical and contemporary materials pertaining to the scientific and artistic aspects of botany. Over 30,000 watercolors, drawings, and original prints make up its collection of botanical imagery. Every five years or so, the Hunt Institute also holds an international exhibition of botanical art and illustration, and these exhibitions are showcases for contemporary artists. The catalogs for them are well worth possessing and are among the Institute's publications in print.

Reference books for the identification of plants can be found in public libraries and especially in the great libraries of botanical gardens. For the person wishing to identify native wild plants, many field guides are available in bookstores. These invaluable small volumes cover wildflowers, trees, ferns, mushrooms, grasses, and sedges. Garden encyclopedias describe both wild and cultivated plants, while many books have been published devoted to individual plant families such as orchids, roses, lilies, and composites, to name only a few.

Here are some of the botanical books I have found most helpful.

Allison, Ellyn Childs, ed., English edition. *Besler Florilegium*. New York: Harry N. Abrams, Inc., 1989.

Anderson, Frank J. *A Treasury of Flowers*. New York: Sammis Publishing, 1990.

Angel, Marie. *Cottage Flowers*. London: Pelham Books, Ltd., 1980.

Bianchini, Francesco, and Francesco Corbetta. *The Complete Book of Fruits and Vegetables*, illust. Marilena Pistoia. New York: Crown Publishers, 1975.

————. *Health Plants of the World*, illust. Marilena Pistoia. New York: Newsweek Books, 1979.

Blunt, Wilfred. *Tulipomania*, illust. Alexander Marshall. Hammondsworth, Middlesex, England: Penguin Books, 1950.

————. *The Art of Botanical Illustration*. London: Collins, 1967.

————. *The Compleat Naturalist, A Life of Linnaeus*. New York: Viking Press, 1971.

————. *Tulips and Tulipomania*, illust. Rory McEwen. London: The Basilisk Press, 1977.

Borland, Hal. *The Lore and Legends of Flowers*, illust. Anne Ophelia Dowden. New York: Thomas Y. Crowell Co., 1982.

de Bray, Lys. *Fantastic Garlands*. London: Blandford Books, Ltd., 1982.

————. *The Art of Botanical Illustration*. Secaucus, N.J.: The Wellfleet Press, 1989.

Calmann, Greta. *Ehret, Flower Painter Extraordinary*. Boston: New York Graphic Society, 1977.

Chwast, Seymour, and Emily Blair Chewning. *The Illustrated Flower*. New York: Harmony Books, 1977.

Cottlesloe, Gloria, and Doris Hunt. *The Duchess of Beaufort's Flowers*. Exeter, England: Webb and Bower, 1983.

Dalton, Patricia A. *Wildflowers of the Northeast*, illust. Amy C. Storey.

Canaan, N.H.: Phoenix Publishing Co., 1977.

Desmond, Ray. *Wonders of Creation: Natural History Drawings in the British Library*. London: British Library Board, 1986.

Dowden, Anne Ophelia. *The Blossom on the Bough*. New York: Thomas Y. Crowell, 1975.

————. *State Flowers*. New York: Thomas Y. Crowell, 1984.

————. *From Flower to Fruit*. New York: Thomas Y. Crowell, 1984.

Ehret's Flowering Plants. New York: Harry N. Abrams, 1987.

Evans, Henry. *Botanical Prints*. New York: W.H. Freeman and Co., 1977.

Foord, J. *Decorative Plant and Flower Studies*. New York: Dover Publications, 1982.

Foshay, Ella M. *Reflections of Nature*. New York: Alfred A. Knopf, Inc., 1984.

Gordon, Lesley. *A Country Herbal*. Exeter, England: Webb and Bower, 1980.

Graham, Robin. *Slipper Orchids: The Art of Digby Graham*. Frenchs Forest, New South Wales, Australia: A.H. and A.W. Reed, 1983.

Grierson, Mary. *An English Florilegium*. New York: Thames and Hudson, Ltd., 1983.

Holden, Edith. *The Country Diary of an Edwardian Lady*. Exeter, England: Webb and Bower, 1977.

Hultan, Paul, and Lawrence Smith. *Flowers from East and West*. London: British Museum Publications, 1979.

Jackson, H.A.C. *Mr. Jackson's Mushrooms*. Ottawa, Ont.: National Gallery of Canada, 1979.

Jenkins, David T. *Mushrooms: A Separate Kingdom*, illust. Loni Parker. Birmingham, Ala.: Oxmoor House Inc., 1979.

Kaden, Vera. *The Illustration of Plants and Gardens, 1500-1800*. London: Victoria and Albert Museum, 1982.

Kerr, Jessica. *Shakespeare's Flowers*, illust. Anne Ophelia Dowden. New York: Thomas Y. Crowell Co., 1969.

King, Ronald. *Botanical Illustration*. New York: Clarkson Potter, 1978.

Koch, Kenneth. *From the Air*, illust. Rory McEwen. London: Taranman, 1979.

Koreny, Fritz. *Albrecht Durer and the Animal and Plant Studies of the Renaissance*. New York: Little, Brown & Co., 1985.

Krieger, Louis C. C. *The Mushroom Handbook*. New York: Dover, 1967.

Leet, Judith. *Flowering Trees and Shrubs: The Botanical Paintings of Esther Heins*. New York: Harry N. Abrams, 1987.

Leonard, Elizabeth. *Painting Flowers*. New York: Watson-Guptill, 1986.

Lerner, Carol. *A Biblical Garden*. New York: William Morrow & Co., 1982.

Mabey, Richard. *The Flowers of Kew*. New York: Atheneum, 1989.

———. *The Frampton Flora*. New York: Prentice-Hall, 1986.

Matthews, Brian. *P. J. Redouté: Lilies and Related Flowers*. Woodstock, N.Y.: Overlook Press, 1987.

Mee, Margaret. *Flowers of the Amazon Forests*. Woodbridge, Suffolk, England: Nonesuch Expeditions, 1989.

Mierhoff, Annette. *The Dried Flower Book*, illust. Marijke den Boer-Vlamines. New York: E. P. Dutton, 1981.

Montadoro, Arnoldo, ed. *Roses for an Empress*. London: Sidgewick and Jackson, 1983.

Moreton, Oscar. *The Auricula*, illust. Rory McEwen. London: Ariel Press, 1964.

Nelson, Charles: *An Irish Florilegium*, illust. Wendy Walsh. New York: Thames and Hudson, 1983.

Parsons, Alfred. *A Garden of Roses*. Topsfield, Mass.: Salem House, 1987.

Paterson, John, and Catherine Paterson. *Consider the Lilies*, illust. Anne Ophelia Dowden. New York: Thomas Y. Crowell, 1986.

Pedretti, Carlo. *Leonardo da Vinci: Nature Studies from the Royal Library, Winsor Castle*. New York: Johnson Reprint Corp., 1981.

Peroni, Laura. *The Language of Flowers*, illust. Marilena Pistoia. New York: Crown, 1985.

Raphael, Sandra. *An Oak Spring Silva*. New Haven, Conn.: Yale University Press, 1990.

Readers Digest Association, Inc. *Magic and Medicine of Plants*, illust. Mary Kellner. Pleasantville, N.Y., 1986.

Redouté, Pierre-Joseph. *Beautiful Flowers and Fruits*. New York: Harrison House, 1985.

———. *Les Liliacees*. Catalog from Sotheby's, New York, 1985.

———. *Roses*. San Dimas, Calif.: Miller Graphics, 1978.

———. *Roses for an Empress*, ed. Arnoldo Montadoro. London: Sidgewick and Jackson, 1983.

Rinaldi, Augusto, and Vassili Tyndalo. *The Complete Book of Mushrooms*. New York: Crown, 1974.

Rix, Martin. *The Art of the Plant World*. Woodstock, N.Y.: Overlook Press, 1981.

Scrase, David. *Flowers of Three Centuries*. Catalog of International Exhibitions Foundation, 1983.

Stearn, William T. *Botanical Masters*. Englewood Cliffs, N.J.: Prentice Hall, 1990.

Thomas, Graham Stuart. *Complete Flower Paintings and Drawings*. New York: Harry N. Abrams/Saga Press, 1987.

Van Ravensway, Charles. *Drawn from Nature: The Botanical Art of Joseph Prestele and Sons*. Washington, D.C.: Smithsonian Institute Press, 1984.

———. *A Nineteenth Century Garden*. New York: Universe Books, 1977.

TECHNICAL RESOURCES

For information regarding techniques both in watercolor and in black and white media, as well as in pricing, printing, publishing, and so on, the following books are extremely helpful.

CBE Style Manual, 5th ed. Bethesda, Md.: Council of Biology Editors, Inc., 1983.

Council of Biology Editors. *Illustrating Science: Standards for Publication.* Bethesda, Md.: 1988.

Dalley, Terence. *The Complete Guide to Illustration and Design, Techniques and Materials.* Secaucus, N.J.: Chartwell Books, 1980.

Guptill, Arthur. *Color in Sketching and Rendering.* New York: Reinhold Publishing, 1935.

Graphic Artists Guild Handbook: Pricing and Ethical Guidelines, 5th ed. New York: Graphic Artists Guild, 1984.

Hodges, Elaine R.S. *The Guild Handbook of Scientific Illustration.* New York: Van Nostrand Reinhold, 1989.

Holmgren, Noel H., and Bobbi Angell. *Botanical Illustration: Preparation for Publishing.* New York Botanical Garden, 1986.

Johnson, Cathy. *Painting Nature's Details in Watercolor.* Cincinnati: North Light, 1987.

Karwoski, Richard. *Watercolor Bright and Beautiful.* New York: Watson-Guptill, 1988.

Leonard, Elizabeth. *Painting Flowers.* New York: Watson-Guptill, 1986.

Leslie, Clare Walker. *Nature Drawing: A Tool for Learning.* Englewood Cliffs, N.J.: Prentice-Hall, 1980.

Meyer, Ralph. *The Artist's Handbook of Materials and Techniques,* 6th ed. New York: Viking Penguin, 1988.

Pocket Pal: A Graphic Arts Production Handbook, 13th ed. New York: International Paper, 1986.

West, Keith. *How to Draw Plants.* New York: Watson-Guptill, 1983.

Wood, Phyllis. *Scientific Illustration.* New York: Van Nostrand Reinhold, 1982.

ACKNOWLEDGMENTS

Supplying text and pictures for a book and describing the use of a watercolor brush in written words has been a tremendous undertaking. It would not have been possible without the help of many individuals—some old and dear friends, others who have become friends along the way. My deep and lasting thanks to:

First and foremost, Candace Raney and Janet Frick of Watson-Guptill, for their constant guidance and unfailing good cheer as they led me through the forest that comprises the world of editing and publishing.

Howard P. Johnson of Communigrafix, Inc., who took special pains to design a lovely book, and his assistant, Jill Radcliffe, for her loving transportation of my artwork.

Ellen Greene of Watson-Guptill, for her careful supervision of the color reproduction and printing.

Whitney Lane of Lane Photography Studio, for much-needed professional advice, beautiful photography, and his personal enthusiastic support for this project.

Marie and Leonard Alpert of Images Gallery, who have promoted and sold my pictures over the years, for their understanding and patience.

Paul Spletzer, my friend and confidant, for his wisdom, sagacity, calm advice, and ongoing interest in this book.

My many comrades in art: Bobbi Angell, Elissa Gore, Patricia Kay, Katie Lee, Carol Cox Lyons, Carol Ann Morley, Richard Rauh, Charlotte Ricks, Roberta Rosenthal, Tony Salazar, Dolores Santoliquido, Redenta Soprano, Louisa Rawle Tiné, and Ed Zaremba, most of whom are fellow instructors of botanical illustration in one form or another at the New York Botanical Garden.

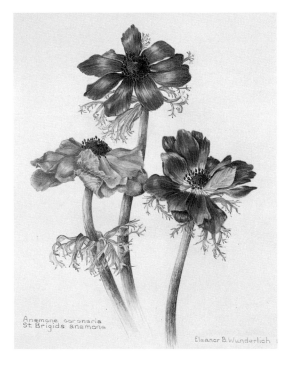

ST. BRIGID ANEMONE

(Anemone coronaria)
WATERCOLOR ON
T. H. SAUNDERS WATERFORD
140 LB. HOT-PRESSED PAPER,
1989, 12 × 8½" (30 × 21 CM).
PRIVATE COLLECTION.

INDEX